# BETTER PICTURE GUIDE TO
## Black & White
### photography

RotoVision

A RotoVision Book
Published and Distributed by RotoVision SA
Rue Du Bugnon 7
CH-1299 Crans-Prés-Céligny
Switzerland

Tel:   +41 (22) 776 0511
Fax:  +41 (22) 776 0889

RotoVision SA, Sales & Production Office
Sheridan House, 112/116A Western Road
Hove, East Sussex BN3 1DD, England

Tel:   +44 (0) 1273 72 72 68
Fax:  +44 (0) 1273 72 72 69

Distributed to the trade in the United S
Watson-Guptill Publications
1515 Broadway
New York, NY 10036

ISBN 2-88046-327-0

Book design by Brenda Dermody

Production and separations in Singapore by ProVision Pte. Ltd.
Tel:   +65 334 7720
Fax:  +65 334 7721

# BETTER PICTURE GUIDE TO

# Black & White
## photography

## MICHAEL BUSSELLE

# Contents

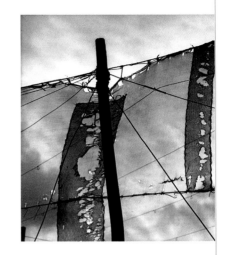

# The Image

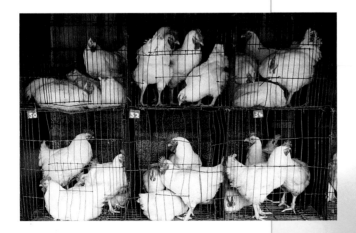

1

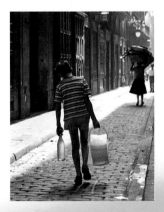

We live in a colourful world, but for nearly a hundred years after the medium of photography was first invented, most images produced were in black and white and seeing in monochrome became second nature to photographers. But colour images are now so commonplace that it requires a quite different way of looking at things in order to create telling black-and-white images. Indeed, most professional photographers dislike having to shoot both black-and-white and colour during the same session as they each need such a radically different approach.

Creating a black-and-white photograph
involves looking at things in a rather different way, seeing in terms of forms,
textures, shapes and tones and learning not to be distracted by colours.

## Technical Details
▼ 6x6cm Twin Lens Reflex – 75mm lens, Ilford FP3 developed in Unitol.          The flea market – Paris.

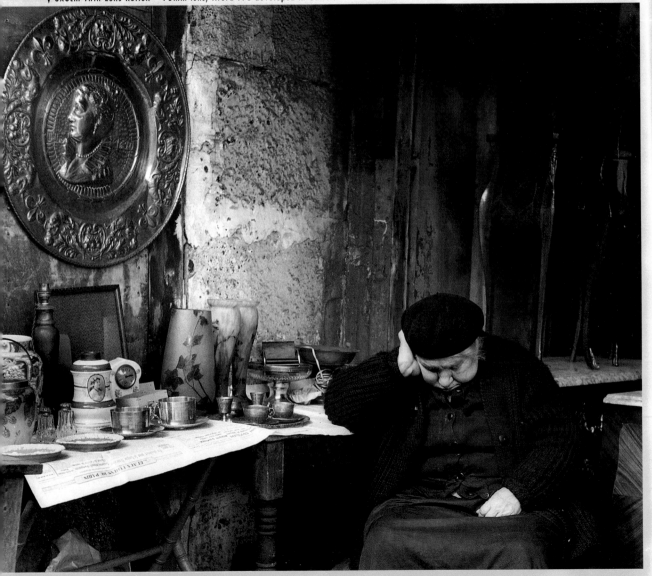

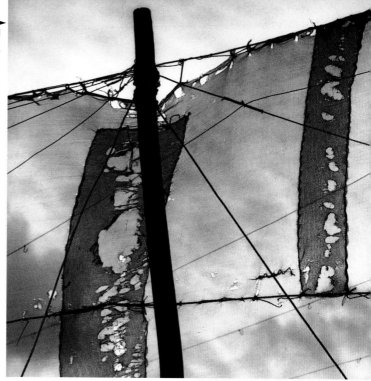

**Technical Details**
6x6cm Single Lens Reflex – 150mm lens, Ilford XP1

A hop field near Goudhurst – Kent, UK.

Although silhouetted against the sky, the translucent nature of this protective screen has yielded an image with a full range of tones and an interesting texture and pattern.

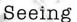

## Seeing

Initially it was the old lady dozing which caught my eye but I felt the brass plaque on the wall would also help to create a strong black and white image.

## Thinking

I wanted to frame the image as tightly as possible to ensure the relatively small detail of her down-turned face was not lost. I looked first at a viewpoint further to my right which placed the plaque much closer to her but her face and pose were not so well shown from there.

## Acting

I chose instead to shoot her from almost front-on which allowed me to have her in one corner of the image and the plaque in the other which, I felt, created a pleasing balance. I made the print as dark as it would go before losing detail in the shadows. The white newspaper needed to be burned in and her face slightly dodged out.

The Darenth valley – Kent, UK.

It is the interesting shape of this silhouetted tree contrasted against the subtle silvery tones of the sky which made this image work for me.

**Technical Details**
35mm Single Lens Reflex – 75-300mm zoom lens, Ilford XP2.

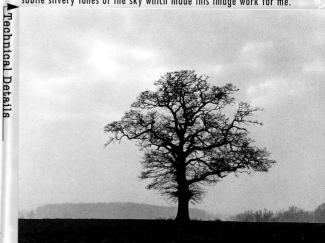

## Seeing

The juxtaposition of the poster and the penned sheep amused me and seemed to make a comment about the power of advertising.

## Thinking

I wanted to have the poster as large as possible and to have it fairly front-on to the camera. But I also needed to have as many of the sheep in the image as I could manage. The fact that the model in the photograph was looking directly at the camera has helped to retain the impact of the poster even though I had to shoot it at an angle.

### Rule of Thumb

The level of contrast is an important factor in creating a pleasing black and white image. Too much and it becomes harsh and jarring, too little and the print will be flat and lifeless. A good way of judging contrast is to view the subject with your eyes half closed.

### Technical Details

▼ 35mm Single Lens Reflex – 35–70mm zoom lens, Ilford FP4 developed in Unitol.

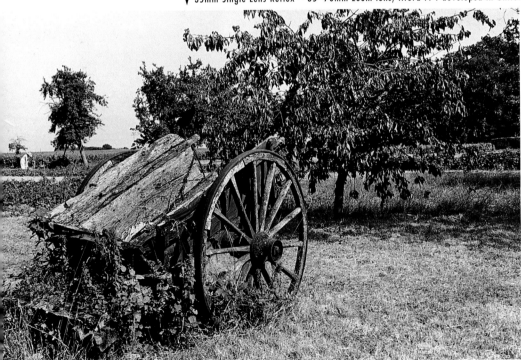

A farm near Tours – Loire valley, France.

The old farm cart had both an appealing shape and a rich texture and would have made a good close-up image. But I wanted this picture to have a more scenic quality so I chose a viewpoint and framed the image in a way which enabled me to place the cart on the left side of the image, with the grass and trees on the right-hand side. The highlights on the leaves also created a strong textural effect which helped to balance the interest of the cart.

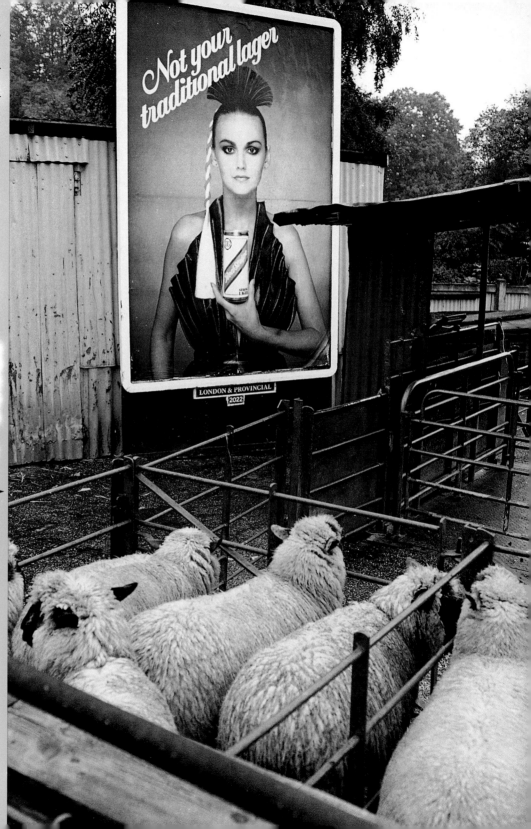

## Acting

I chose a close
viewpoint and
used a wide-angle
lens so that I
could obtain the
best balance
between these
two features. The
lighting and
resulting negative
were quite soft so
I printed on a
**hard-grade
paper** to give
the image a
degree of punch.

▲ **Technical Details**
35mm Single Lens Reflex – 24mm lens, Kodak Tri X developed in D76.

# Light & Form

One of the most fascinating aspects of photography is that it's possible for an image to create a strong impression of three dimensions on a flat piece of paper. In many ways this effect can be more striking with a black and white image than with a colour photograph. This is because we are more aware of the subtleties of tone within the image when colour is not there to distract us. It's largely the way in which the tones are distributed in the image which creates the impression of form and depth and this in turn is mainly dependent upon the way a subject is lit.

### Seeing
It was the strong side lighting which made this scene appeal to me since it created a bold impression of form within the contours of the landscape as well as a rich texture.

### Thinking
I wanted to emphasise the shape of the rocky knoll and to make use of the footpath below it as an element of the composition.

### Acting
I chose a viewpoint which placed as much as possible of the hill's outline against the sea and sky and used a long-focus lens to frame the image quite tightly. I printed the negative on a hard-grade paper to accentuate the strength of the shadows and enhance the impression of texture.

The Studio.

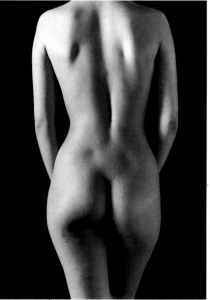

**▲ Technical Details**
6x6cm Single Lens Reflex – 150mm Lens
Ilford FP4 developed in Unitol.

I wanted to show the soft roundness of this young woman's back and used a single light source with a diffusing screen, almost at right angles to her, in order to produce a strong degree of modelling but without creating excessive contrast. This was helped by adding a large white reflector quite close to her on the opposite side. The use of a black background has helped to give the image a more luminous quality and I printed the negative to obtain a full range of tones.

Valley of the Rocks, Near Lynton – North Devon, UK. ▲ Technical Details
6x4.5cm Single Lens Reflex – 105–210mm zoom lens, Ilford XP.

A field in the Algarve — Portugal.

For this image I wanted to reduce the impression of form in order to create a soft and flattering effect on the model's face and, for this reason, took the photograph into the light using a silver reflector to bounce some light back on to her. This has almost eliminated the shadows on her face and I have weakened them further by making a lightish print on a soft-grade paper.

Technical Details ►
6x6cm Single Lens Reflex — 150mm lens,
Ilford FP4 developed in ID11.

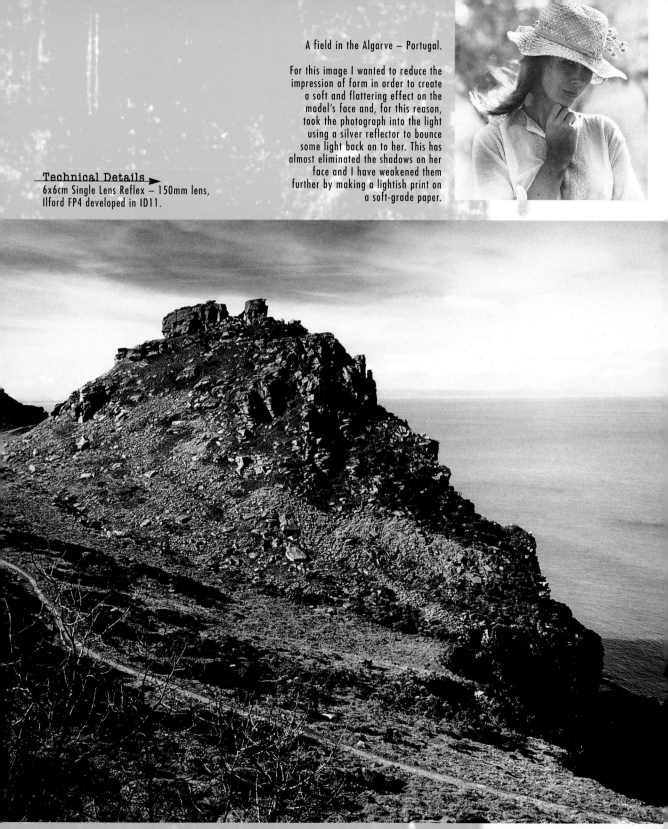

## Seeing

The interaction between the wood carver's hands and his work were what attracted me about this image, as well as the wonderful quality of the light from a window which was creating a strong impression of form and texture.

## Thinking

I wanted to emphasise these qualities and to show in the print how subtle but tangible the difference between the wood and the flesh seemed to the eye.

## Acting

I chose a viewpoint from which the angle of the light created the most pleasing effect and framed the subject matter quite tightly to emphasise the tactile quality of the image. The lighting was so sympathetic that the print was quite straightforward on a normal grade of paper and needed virtually no shading.

### Rule of Thumb

Shadows are the key to the quality and direction of light and in turn, how the impression of form is created in an image. If you learn to see how and where the shadows fall, how sharp their edges are and how dense they are, you will soon have a clear understanding of how the lighting affects your subject and how you might best control it.

### Technical Details
▼ 6x4.5cm Single Lens Reflex – 55–110mm zoom lens, Ilford P2.

The Studio.

This still-life shot by Julien Busselle was lit from slightly above the set-up with a diffused light. The image creates a strong impression of form and depth but the reflective surface of the vegetables has produced much stronger highlights and denser shadows than in the previous image and these have been further emphasised in the printing for a more dramatic effect.

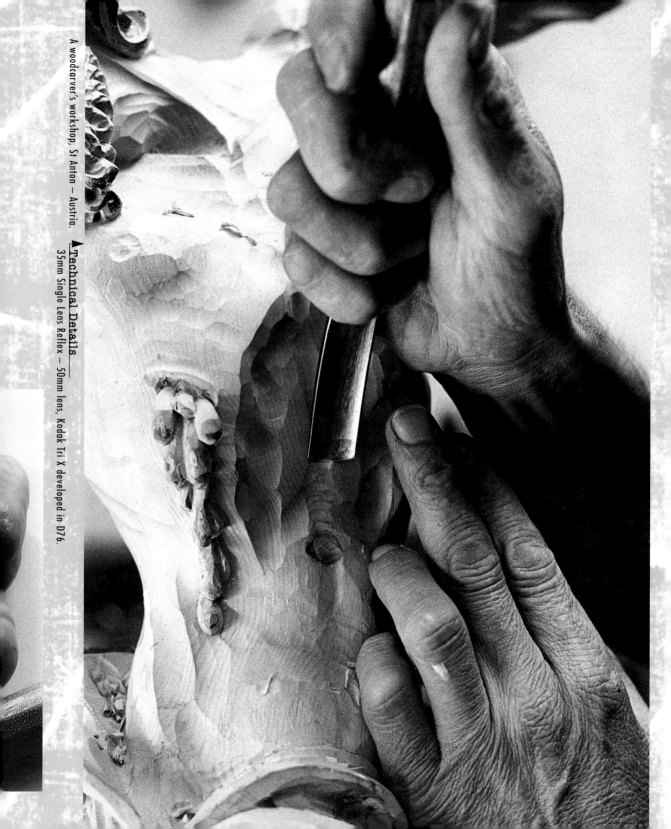

A woodcarver's workshop, St Anton — Austria.

▲ **Technical Details**
35mm Single Lens Reflex — 50mm lens, Kodak Tri X developed in D76.

## Exploiting Texture

The medium of photography is especially effective at conveying an impression of texture and this can be particularly powerful in a black and white image. In effect, texture is the form within an object's surface and needs the same subtleties of an image's tonal range to reveal it effectively. Like form, it is equally dependent upon the direction and quality of the illumination.

## Seeing

Taken on a winter's afternoon, it was the striking effect of the **low-angled sunlight** glancing across this field with its newly emerging crop which made me want to shoot it.

## Thinking

I realised that this alone would not make an interesting composition and I needed an **additional element** to provide a focal point.

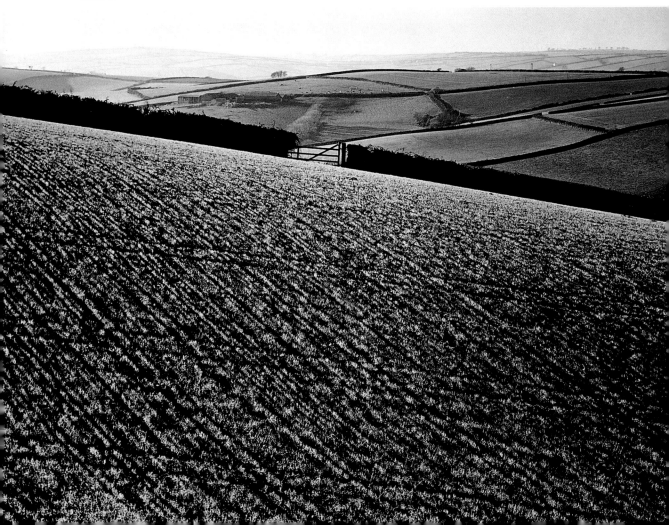

The Studio.

A street in Sevenoaks – Kent, UK.

Shooting into the light is often an effective way of emphasising the texture of a surface like this pavement and drain cover but there is a risk of underexposure in these circumstances and I gave one stop more than indicated for this shot.

### Technical Details
35mm Single Lens Reflex – 105mm lens, Ilford FP4 developed in Unitol.

### Technical Details
6x6cm Twin Lens Reflex – 75mm lens Ilford FP3 developed in Unitol.

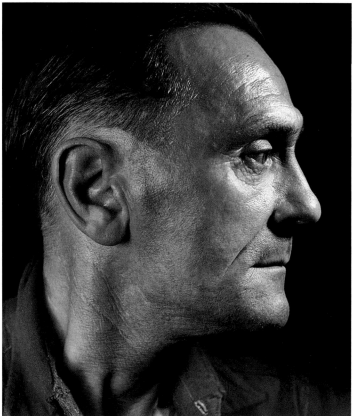

A single undiffused light aimed directly into the subject's face has created a strong textural effect on his skin. I used a white reflector on the opposite side to bounce some light back into the shadows.

## Acting

The distant hedgerow with the field gate and hills beyond were an obvious choice but they were a long way away so I opted to use a long-focus lens to enlarge them in the image and to isolate a small area of the field. The resulting compression of perspective has added a further element of interest to the image and I enhanced the textural quality by making a quite punchy print on a hard-grade paper.

Near Newton Abbot– South Devon, UK.

### Technical Details
6x4.5cm Single Lens Reflex – 300mm lens, Ilford XP2.

## Using Shapes & Forms

While form is the element which gives an object a sense of depth and solidity, it is often its shape which initially identifies it, and shape alone can give an image a powerful and eye-catching quality.

## Seeing

The curious, contorted shapes which the bodies of these two lads created as they sat on the railings made this a must-have picture for me.

## Thinking

I thought that I could emphasise the shapes most strikingly by choosing a viewpoint which placed them with their backs towards me and with the light, plain tone of the sea as a background.

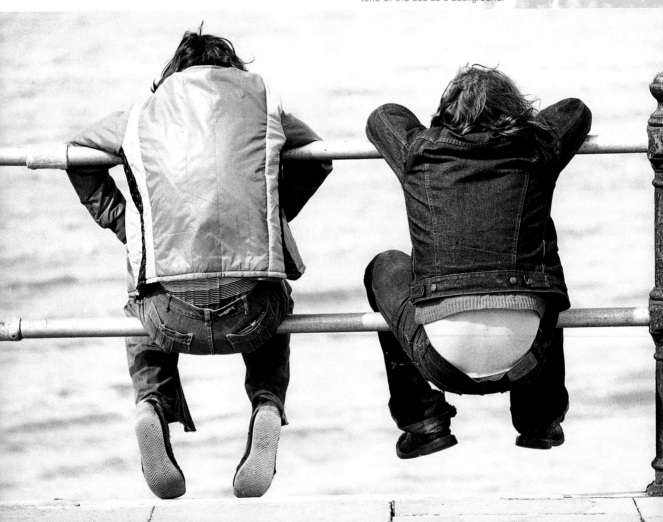

The main factor in creating exploiting the shape of a subject is to ensure there is a good tonal contrast between the subject and its background, like a rusty iron cart wheel propped against a white wall, for instance.

## Acting

I chose a **long-focus** lens to frame them quite tightly and printed on to a **hard-grade** paper so the sea recorded as an almost-white tone which further emphasised the shapes.

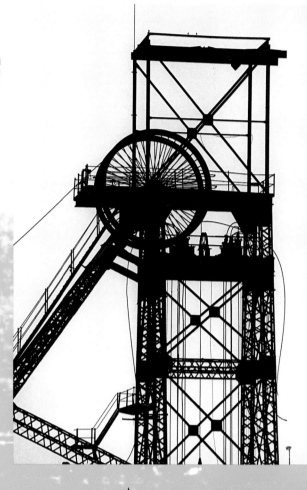

The Rhonda valley – Wales, UK.

This image is a pure silhouette and works simply because of the interest and detail of the pit head's shape. I exposed the print to obtain a faint tone in the sky and to avoid it being stark white.

**Technical Details**
35mm Single Lens Reflex, 150mm lens, Ilford FP4 developed in ID11.

**Technical Details**
35mm Single Lens Reflex – 35mm lens, Ilford XP1.

**Technical Details**
35mm Single Lens Reflex- 150mm lens, Kodak Tri X developed in D76.

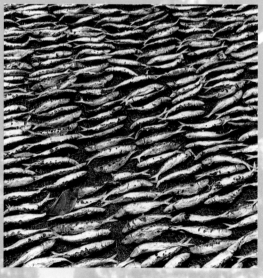

A beach near Negombo – Sri Lanka.

Pattern is when a distinctive shape is repeated within the image and it can have a quite mesmerising effect when used as part of a composition. But pattern alone, as in this shot of sun-dried fish, although initially eye-catching, will seldom give a photograph lasting appeal.

## The Art of Selection

The reason why many photographs disappoint is sim because they contain too much information in the image. You may not be close enough to yo subject, or you haven't framed tightly enough.

There are two basic skills involved in producing good photographs, whether in colour or in black and white: the ability to see the potential in a subject or situation and the understanding of how much of it to include in order to create the most telling image.

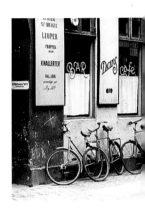

## Seeing

My first thought on seeing this scene was to include the whole of the café façade with its row of bikes and I did this using a fairly **distant viewpoint** and a standard lens.

## Thinking

After I'd made this exposure, I thought that perhaps a **closer image** and a **simpler composition**, which created stronger sense of design, might work better.

## Acting

Using the same lens, I moved closer to the pair of bikes at the head of the row and chose a viewpoint which gave me a more **frontal view** and framed the shot so that just the words 'BAR' and 'Dans' were included in the image. In retrospect I'm not sure which version I prefer.

**Technical Details**
▼ 35mm Single Lens Reflex — 150mm lens, Ilford XP1.

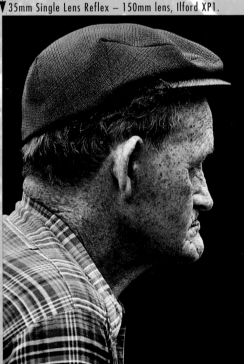

A wine fair in Sigoules — Dordogne, France.

This man's wonderful profile was irresistible, but he was in a group of people and the surroundings were rather cluttered. For this reason, and to emphasise his profile, I used a long-focus lens, combined with a fairly close viewpoint, to exclude all but the essential details.

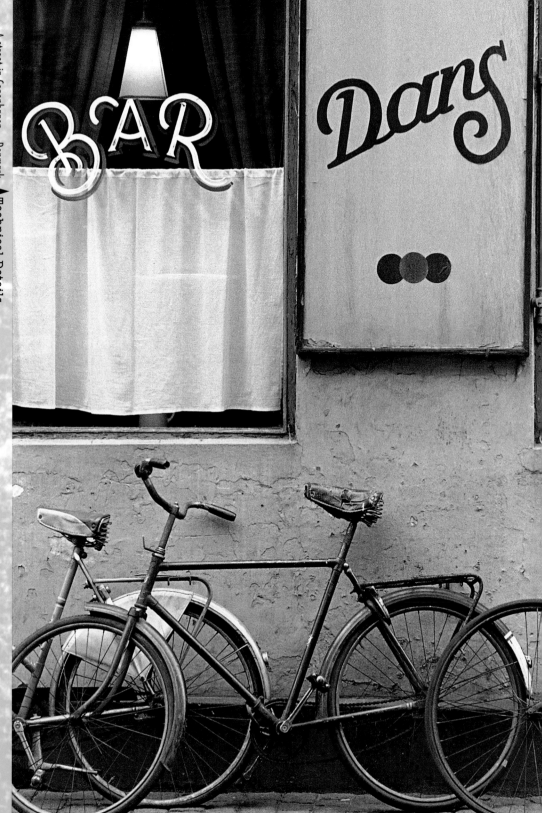

A street in Copenhagen — Denmark. ▲ Technical Details
35mm Single Lens Reflex- 50mm lens, Kodak Tri X developed in D76.

## Seeing

I noticed this rather lonely looking man sitting on a park bench feeding the pigeons and felt it would make an appealing image.

## Thinking

I did not want the man to become aware of me as I felt it would destroy the rather introspective atmosphere of the scene and I also wanted to keep the background as simple as possible.

## Acting

Fortunately, a viewpoint from slightly behind the man achieved both these aims and I used a long-focus lens to frame the image fairly tightly. I decided to include the base of the trees at the top of the frame because I felt that it helped to establish his location and it was necessary to have a little space around him to emphasise the lonely mood of the picture.

## Rule of Thumb

The less you include in an image the more impact it is likely to have. Many disappointing photographs would have been improved if the photographer had taken two or more photographs instead of trying to include all of the scene in one image.

**Technical Details**
▼ 35mm Single Lens Reflex – 200mm lens, Kodak Tri X developed in D76.

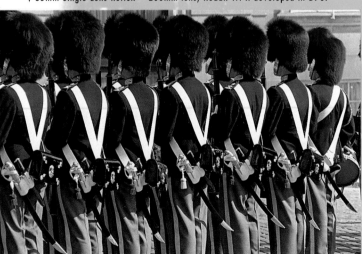

The Royal Palace, Copenhagen – Denmark.

I wanted to emphasise the pattern created by the Royal Guards' webbing and used a long-focus lens to isolate this small area of the scene from a quite distant viewpoint.

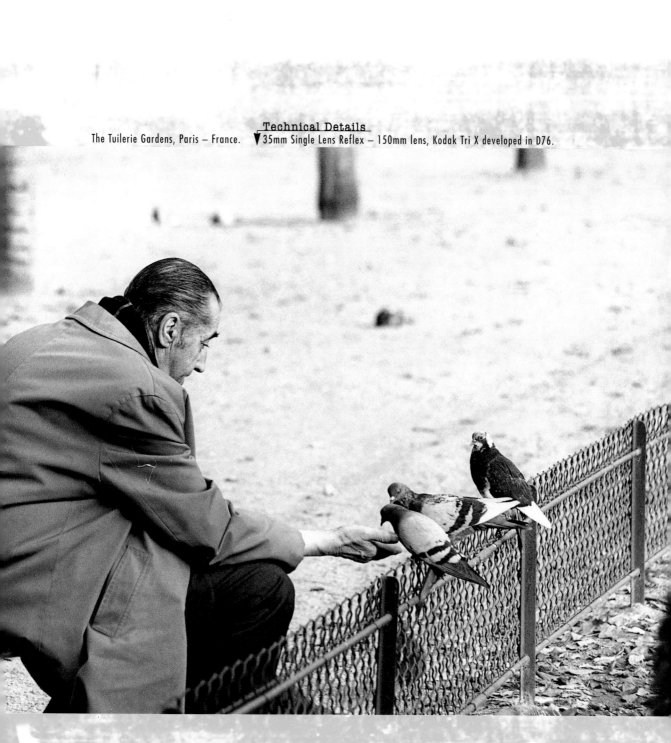

The Tuilerie Gardens, Paris — France.

Technical Details
▼35mm Single Lens Reflex — 150mm lens, Kodak Tri X developed in D76.

# Choosing a Viewpoint

The ability to select a particular aspect of a scene, and to arrange it in the most pleasing way, is largely dependent upon the choice of viewpoint. This is one of the most important decisions a photographer can make before taking a photograph.

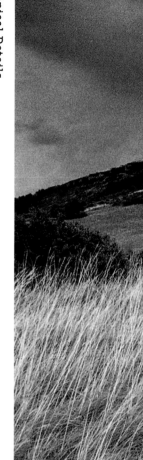

**Technical Details**
35mm Single Lens Reflex — 24mm lens, Ilford FP4 developed in Agfa Rodinal.

## Seeing

As I approached this site my initial interest was triggered by the **curious formation** of the hill with its topmost rock and the very dramatic sky.

## Acting

I decided to continue up the hill away from the rock and found this place where the dried grasses created a quite striking area of **highlight**. I looked for a viewpoint from which I could frame both the grass and distant rock and chose a wide-angle lens to allow the inclusion of a **large area** of both the foreground and sky.

## Thinking

I stopped immediately to take the shot but realised that the very soft lighting and lack of highlights in the distant landscape were likely to create a rather flat and lifeless image.

**Technical Details**
▼ 35mm Single Lens Reflex — 24mm lens, Kodak Tri X developed in Unitol.

The Knesset, Parliament building — Jerusalem, Israel.

The flat lighting on the building and blank sky made an interesting shot seem unlikely but I found that by choosing a viewpoint which allowed me to include the strikingly-shaped detail of the decorative gateway as a silhouetted foreground, and to mask the blank sky, it changed into an effective image.

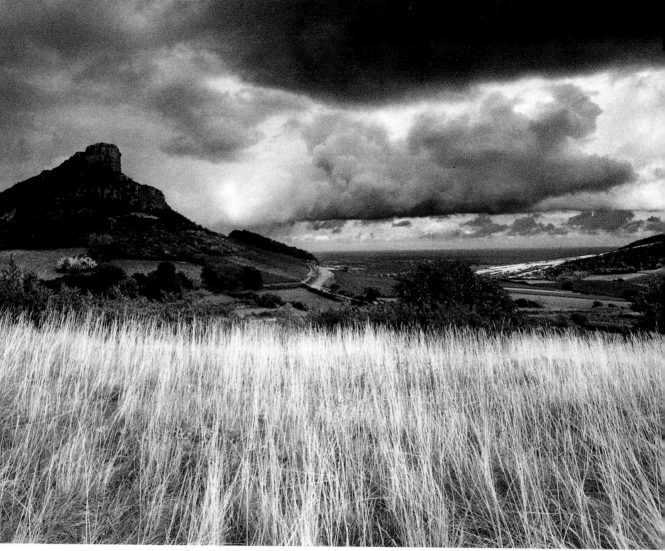

The Rock of Solutre — Burgundy, France.

## Technique

When including foreground and distant details which both need to be in **sharp focus** you need to set a **small aperture** to ensure adequate depth of field.

### Rule of Thumb

Many inexperienced photographers will shoot their photographs from the position at which they first see the subject – as when a group of tourists descend from a coach at a popular tourist site. In some cases there is a need to shoot pictures quickly and instinctively but as a general rule it is important to explore all the possibilities fully before you take the camera from its bag.

# Choosing a Viewpoint

## Rule of Thumb

Moving the camera from left to right can have a major effect on the image's composition. If you move the camera to the right, objects close to the camera will effectively move to the left in relation to background details and vice versa.

## Seeing

This docker caught my eye and I felt there was an interesting shot to be had with the stacked boxes in the background. But the scene was quite muddled and I needed to find a way to simplify it.

### Thinking

I realised that his rather curvaceous profile, which I saw as the main focus of attention in the image, would not show up very well from where I was standing as the boxes behind were very light in tone.

## Technical Details
▼ 6x4.5cm Single Lens Reflex — 50mm lens, Ilford XP2.

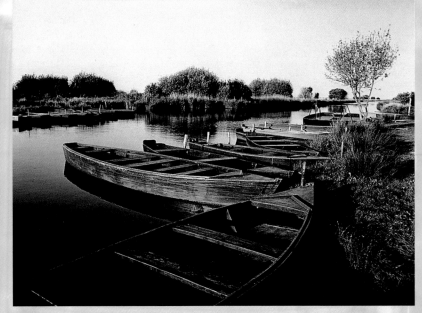

## Technique

Most photographs are taken from eye level, five feet or so above ground level, and one way of creating pictures with greater impact is to use very low or higher viewpoints, when the subject is suitable.

La Grande Briere — Loire Valley, France.

I used a wide-angle lens and a close viewpoint to emphasise the boat in the foreground and give the image a stronger impression of depth and distance.

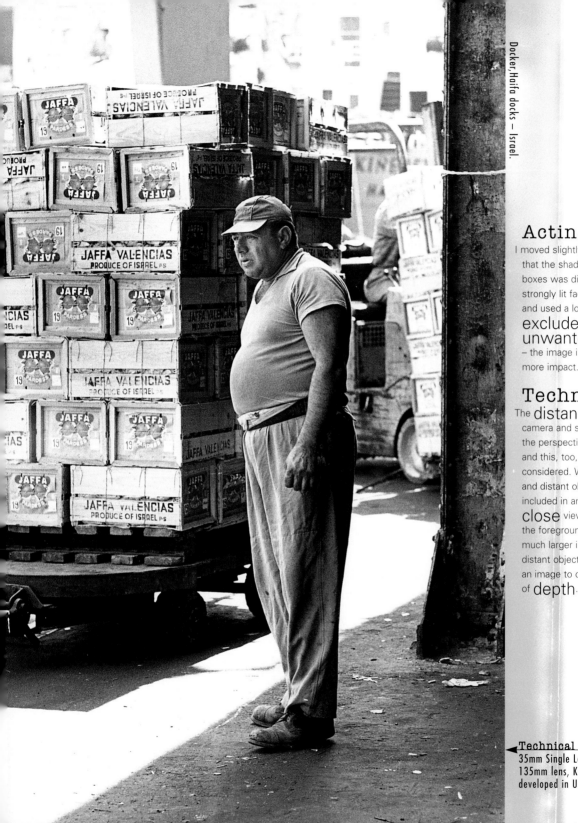

Docker, Haifa docks – Israel.

## Acting

I moved slightly to one side so that the shadowed area of the boxes was directly behind his strongly lit face and stomach and used a long-focus lens to **exclude unwanted details** – the image immediately had more impact.

## Technique

The **distance** between the camera and subject affects the perspective of an image and this, too, needs to be considered. When both near and distant objects are included in an image, a **close** viewpoint will make the foreground object appear much larger in proportion to distant objects. This can help an image to create a feeling of **depth**.

**Technical Details**
35mm Single Lens Reflex – 135mm lens, Kodak Tri X developed in Unitol.

# Framing the Image

There is a widely quoted rule of composition that the image should be framed so that the main point of interest is placed where lines dividing the image into thirds intersect. While this will, in most cases, produce a pleasing effect it is by no means something which should be followed slavishly and it is important to consider the overall balance of the image before deciding on the way it is framed.

## Seeing

This white park bench and the dark privet hedge behind it appealed to me for its simplicity and I could visualise how effective this might look as a black and white image.

## Thinking

I felt that the appeal of the bench was largely because of its stark parallel lines and this would be most effectively shown from a frontal viewpoint.

## Acting

When I began to decide how to frame the image I felt that the best solution was to emphasise the very symmetrical nature of the bench by placing it in the centre of the frame. But I decided to have more space above it than below as the path in the foreground was not very interesting.

### Rule of Thumb

Many inexperienced photographers use a camera's viewfinder like a gunsight, concentrating on the centre of the image and being only vaguely aware of the other details which are included. This often results in the inclusion of unwanted details and a centrally placed focus of interest – which is seldom the best position. It's best to look inwardly from the the edges of the frame, in this way you become more aware of how all the elements of the image relate to each other.

The subject's home.

This portrait by Matt Anker breaks all the rules about framing, and positioning the main focus of interest, with very striking effect. By placing the subject of the portrait close to one side of the frame, and having him looking out of it, Matt had created an image with a strong feeling of tension and ambiguity.

The recreation ground, Sevenoaks – Kent, UK.

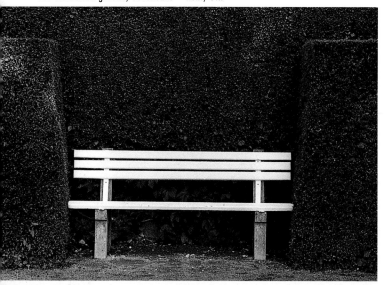

**Technical Details**
6x6cm Single Lens Reflex – 80mm lens, Ilford FP4 developed in ID11.

**Technical Details**
35mm Single Lens Reflex – 50mm lens, Ilford FP4 developed in ID11.

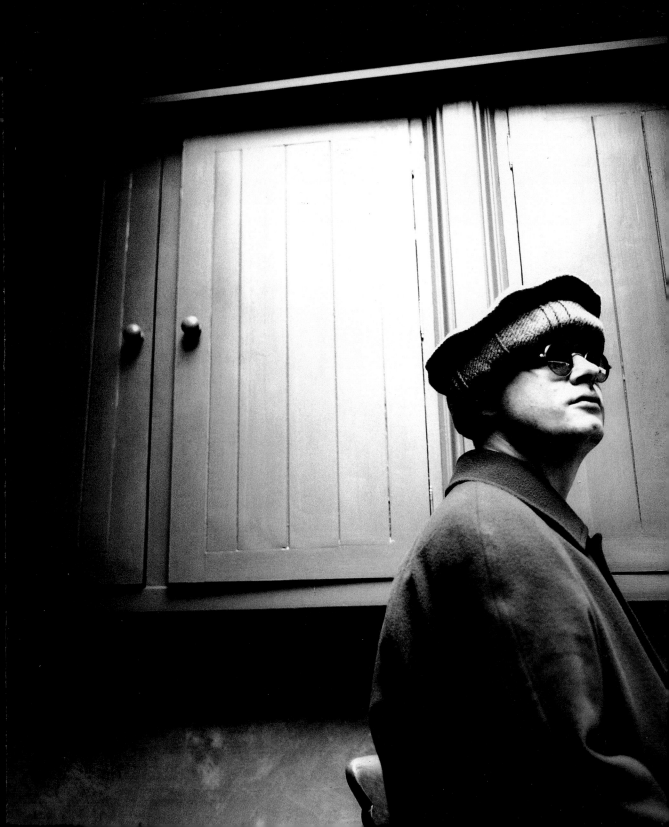

# Framing the Image

The key to framing the image lies in identifying the most dominant feature, which may be a principle object like a house in the midst of an otherwise empty landscape or simply an area of strong highlight or texture.

## Seeing

This small village was in the midst of harvesting and entire families had turned out to help. This young lad attracted my attention and I followed him, looking for a way in which I could photograph him in a natural way.

## Thinking

I thought the ancient farm cart would make an ideal background as it would help to establish the setting and mood of the image.

## Acting

I found a fairly distant viewpoint where the boy was well positioned in relation to the cart and decided to use a long-focus lens to frame the image quite tightly. I adjusted the framing so that almost all of the cart and the figures loading it were included in the image and the boy was placed towards one corner.

### Technical Details
▼ 35mm Single Lens Reflex – 20mm lens, Kodak Tri X developed in Unitol.

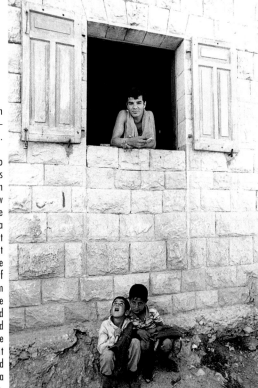

A street in Jerusalem – Israel.

Both the two young boys and the man in the window could have made a satisfying shot separately but I liked the idea of including them in the frame together and had the good luck to capture the moment the boy looked up, creating a perfect link.

### Technical Details
▼ 35mm Single Lens Reflex – 24mm lens, Ilford FP3 developed in Unitol

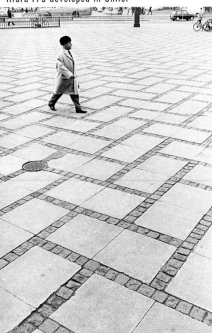

A square in Copenhagen – Denmark.

I used a wide-angle lens and tilted the camera downwards to include a large area of the paving, at the same time placing the man in the top corner of the image, in order to create a more interesting and dynamic composition.

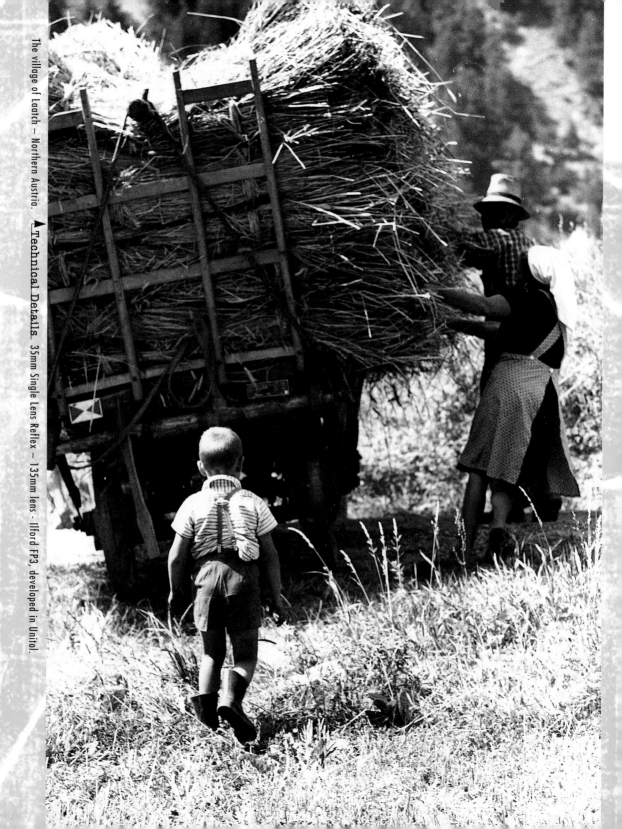

The village of Laatch — Northern Austria. ▲ **Technical Details.** 35mm Single Lens Reflex — 135mm lens - Ilford FP3, developed in Unitol.

## Creating Mood

Mood is an elusive element in a photograph. It's something which can often be present in a situation but is very difficult to convey on film. With colour photography the evocation of mood can often be achieved by the use of colour but in black and white photography it must be done purely by the way the subject is lit and by controlling the tonal range of the image.

## Seeing

Early morning sunlight created a very pleasing effect in this cobbled street but it needed another element to create an interesting image.

Place de la Concorde — Paris, France.

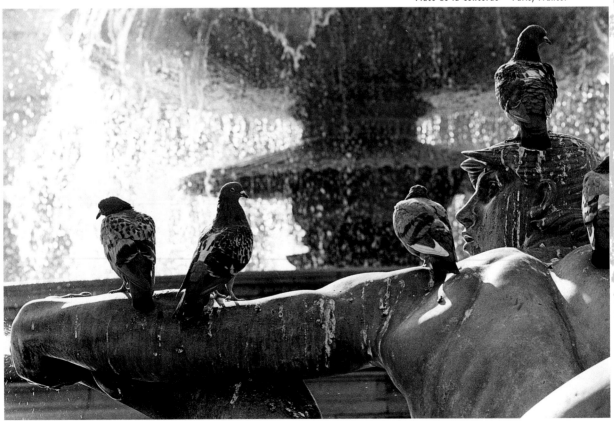

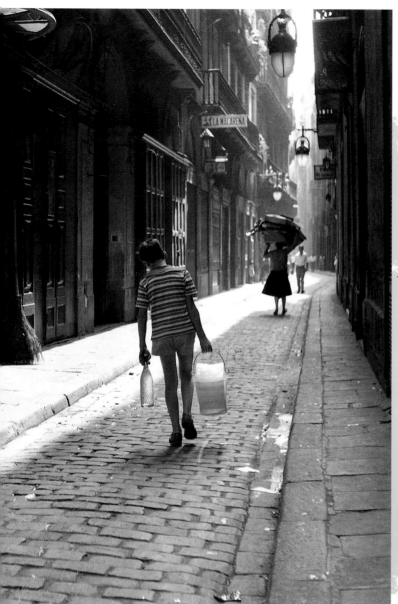

A street in Barcelona – Spain.

## Technical Details
6x6cm Twin Lens Reflex – 75mm lens,
Ilford FP3 developed in Unitol.

## Thinking
People were passing up and down the street as I watched and I thought that the **right person** could provide the necessary focus of interest.

## Acting
I saw this young boy approaching from behind me and I moved to the right-hand side of the street so he would be placed against the shaft of sunlight as he came past and then waited until he walked into the **right position** before making my exposure.

## Technical Details
35mm Single Lens Reflex – 105mm lens,
Ilford FP4 developed in Unitol.

It was the sparkle of this subject which appealed to me, created by the water and the back lighting. I used a long-focus lens to enlarge a detail of the fountain and set a wide aperture to ensure the background details were not distractingly sharp.

# Creating Mood

The tonal quality of the subject can also contribute significantly to the mood of an image. A high-key photograph in which the majority of the tones are at the lighter end of the grey scale will tend to have a tranquil and restful mood while a low-key image in which the tones are predominately dark will have a more threatening and sinister atmosphere.

## Seeing

It was a very grey overcast day with flat lighting when I arrived at this location and the farm itself, reputed to be that upon which Wuthering Heights was based, was not very photogenic.

## Thinking

Even with the light-toned grasses in front of the building, the contrast was very low and I felt the image needed another element to add impact.

## Acting

I decided to move further back and include part of the dry-stone wall which, being dark, would help to increase the contrast. I used a wide-angle lens to allow me to include a large area of the foreground wall and some of the sky. In order to enhance the mood of the scene I printed the negative quite darkly to create a low-key image, printing in both the wall and the sky to keep the tonal range very subdued.

**Technical Details**
35mm Single Lens Reflex –
24mm lens, Kodak Tri X
developed in D76.

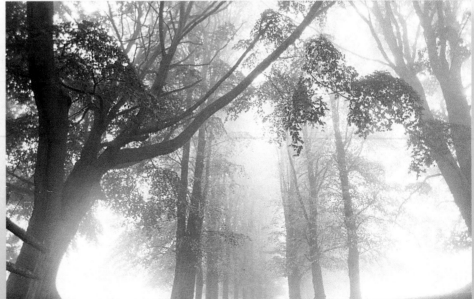

A Lane near Sevenoaks – Kent, UK.

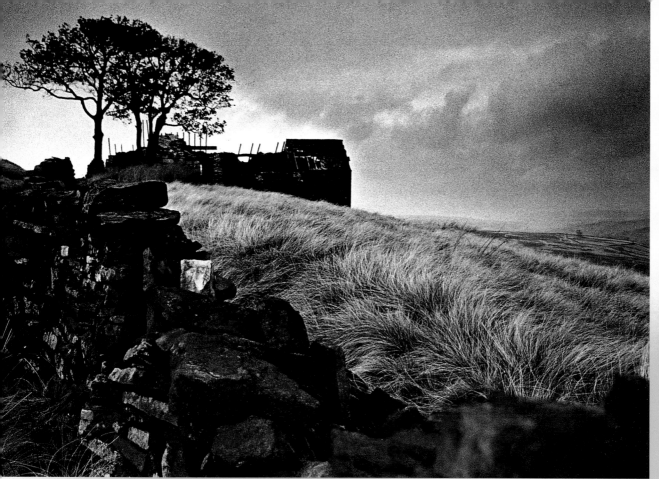

Top Within Farm Near Howarth — Yorkshire, UK.

Technical Details

35mm Single Lens Reflex — 20mm lens, Ilford FP4 developed in Unitol.

This was a very misty morning with limited visibility and the conditions reduced this scene to one of simple shapes. I decided to use a wide-angle lens so that I could tilt the camera up towards the sky and use the resulting distorted shapes of the trees as a feature of the composition. I overexposed the negative by one stop to help create a high-key image and printed it quite lightly on to a soft-grade paper to retain the gentle feel.

There are many different reasons for taking photographs – as a straightforward record of a place or event, for instance; for purely pictorial reasons; as a means of personal expression; to tell a visual story; to reveal social injustice or simply for the pleasure of practising a craft.

## Seeing

It was the very silveriness of these silver birch trees which made me want to photograph this scene.

## Thinking

I did not want it to be a pretty, calendar-style image, which is partly why I opted for a black and white photograph, and I did not want it to look too designy.

## Acting

I chose a viewpoint which featured a section of the trees where they were growing at a slanting angle and framed the shot in a way which made them look a bit untidy. I printed the negative quite richly on to a hard-grade paper to emphasise the silvery quality and texture of the highlighted tree trunks.

### Rule of Thumb

Motivation and direction are two of the most important factors in producing good photographs. It helps a great deal to have specific aims. Working on a particular project is an invaluable way of establishing an approach to a subject and of developing a personal style – even if it is something you have set yourself.

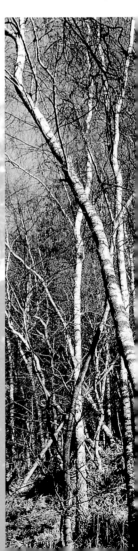

**Technical Details** ▶
6x4.5cm Single Lens Reflex – 55–110mm zoom lens, Ilford XP2.

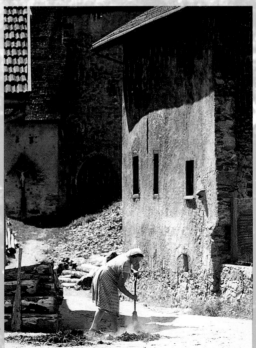

A village in the Arlberg – Austria.

This photograph is what I regard as pictorial reportage. I've adopted a very straightforward approach but the quality and mood of the lighting has prettified the image making it, perhaps, more decorative than a purely documentary photograph would be.

**Technical Details** ▶
6x6cm Twin Lens Reflex – 75mm lens, Ilford FP3 developed in Unitol.

Littlestone Beach – Kent UK.

I found this scene very amusing. It has little pictorial merit and is not exactly great art but I found it an irresistible subject and one which a newspaper or magazine might well appreciate. I framed the image quite tightly, using a long-focus lens, and made a fairly hard, light print to accentuate the figures and keep the background light toned and undistracting.

Technical Details
35mm Single Lens Reflex –
150mm lens, Ilford FP4
developed in Unitol.

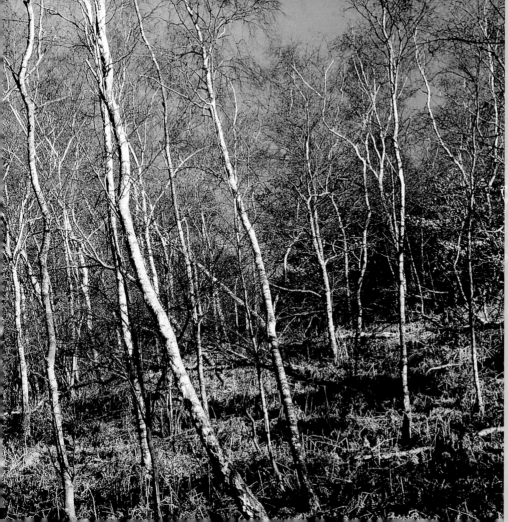

Woods near
Sevenoaks–
- Kent, UK.

## Choosing the Moment

One of the unique things about photography is its ability to record a precise and very brief moment in time. For this reason, choosing the moment at which an exposure is made can be a crucial factor in deciding the significance, composition and effect of an image.

### Seeing

I saw this boy with his young brother and felt sure there was going to be the possibility of a picture. I followed him for a while as he walked along the opposite side of the street, looking for a viewpoint.

### Thinking

He suddenly decided to cross the road and I realised that as he did so he would be separated from the houses lining the street and my chance of an uncluttered shot would present itself.

### Acting

I made one exposure as he reached the middle of the road but he was still not completely clear of the houses behind him and the image still seemed too confusing. At this moment, as he lifted the push chair to mount the pavement, the picture seemed to come together suddenly and I made this exposure.

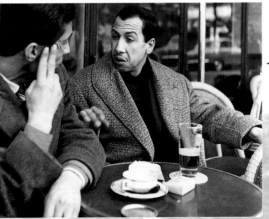

A pavement Café in the rue de Rivoli, Paris – France.

I'd watched these two men for a while and had already made one exposure as they talked. It was this sudden gesture and the man's animated expression which changed it from being a fairly ordinary street shot to one with a sense of spontaneity and a degree of impact.

**Technical Details**
6x6cm Twin Lens Reflex – 75mm lens, Ilford FP3 developed in Unitol.

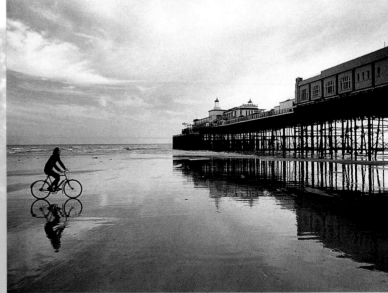

Technical Details
▼ 35mm Single Lens Reflex — 105mm lens, Kodak Tri X developed in Unitol.

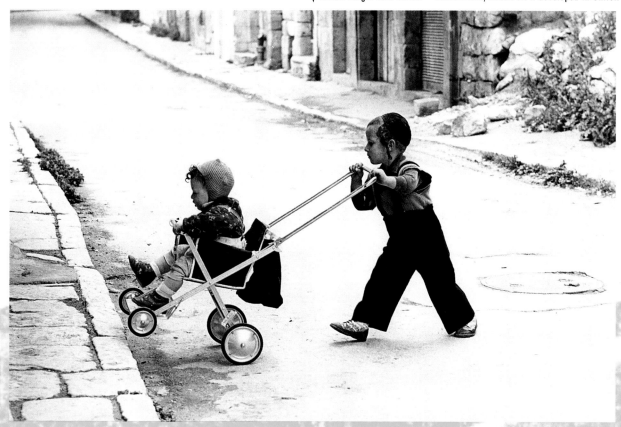

A street in the Orthodox Quarter, Jerusalem — Israel.

◄ Technical Details
35mm Single Lens Reflex — 50mm lens, Ilford FP4 developed in ID11.

Hastings pier — East Sussex, UK.

I saw this cyclist approaching as I was photographing the pier and realised that if I could find the right viewpoint in time he would make an ideal focus of interest. I had only a few seconds to find this spot and one brief chance to make the exposure when he reached this crucial point.

## Design & Abstraction

For the majority of photographs it is the subject which is the prime
motivation for taking it and the way in which it is lit or composed is simply a means of creating the most
telling result. But an awareness of lighting qualities and being able to recognise the potential of composition
can be a strong enough factor to make the subject a secondary consideration. Considerable satisfaction can be
derived from producing a striking image from a very ordinary or mundane subject.

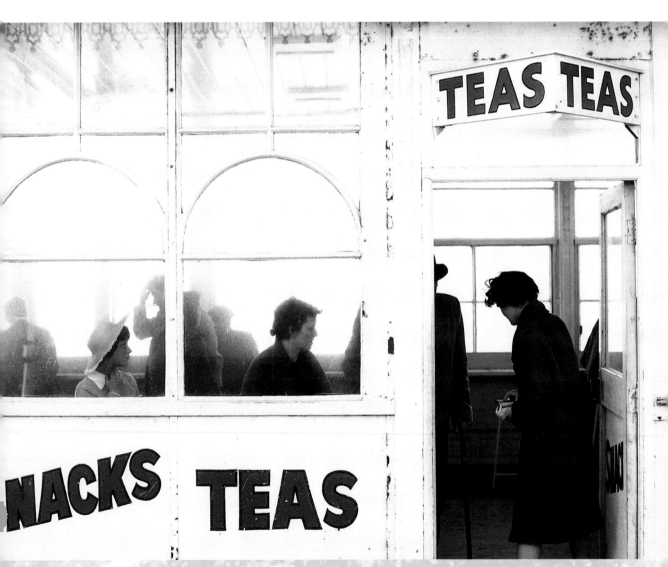

A Café on Brighton Pier — Sussex, UK.

## Technique

A large degree of abstraction and design can often be created by the **photographic** process itself, particularly in black and white when printing techniques can be used to **transform** a relatively normal image into something quite different.

**Technical Details**
35mm Single Lens Reflex – 105mm lens, Ilford FP4 developed in ID11.

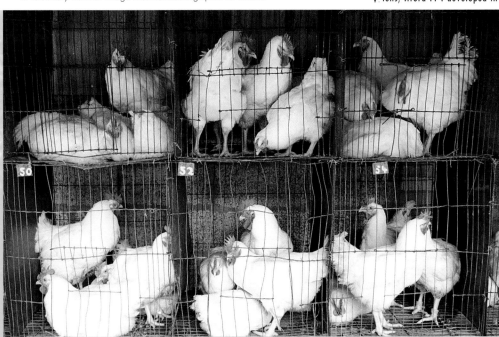

Sevenoaks Market – Kent, UK.

Although it seemed a fairly unlikely subject, I felt that the random pattern effect created by the birds in their cages had changed the image from being a simple record shot of market livestock to something which had a slightly unreal, abstract quality.

## Seeing

It was the **bold contrast** between the white-painted façade, the **semi-silhouetted** figures and the black lettering which appealed to me in this café scene.

## Thinking

I needed a **viewpoint** which allowed me to see through the café doorway and windows quite clearly to make the most of the figures and I tried **several** positions before settling for this one.

## Acting

I used a **long-focus** lens to frame the image quite tightly and waited for the woman to be framed in the doorway before shooting. I printed the negative on to a **hard-grade paper** and gave just enough exposure to produce rich, dark tones but only a faint tone in the lighter areas as I wanted the print to have an almost **'soot and whitewash'** quality.

**Technical Details**
35mm Single Lens Reflex – 105mm lens, Kodak Tri X developed in D76.

The Subject

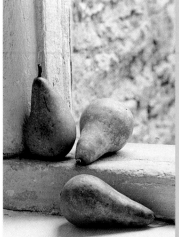

# 2

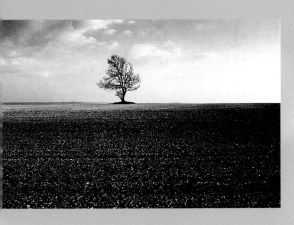

Each of the most frequently
photographed subjects requires a
particular approach and, often, special technical skills which will help towards the production
of striking black and white images. There is also the possibility that a style and technique
which has been developed for one particular type of subject can often be modified and
adapted successfully for an entirely different one.

# The Landscape

The landscape is one of the most popular subjects for photographers and for those working in black and white it has a special appeal. One reason is that it's very accessible – good landscape photographs can be taken almost anywhere and some of the finest images in this genre are not of spectacular views but ordinary scenes and details which have been transcribed into powerful images by a keen eye and skillful use of the medium.

A field near Wylie – Wiltshire, UK. **Technical Details** 6x4.5cm Single Lens Reflex – 105–210mm zoom lens, Ilford XP2.

## Seeing

I saw this lone tree from the road as I was driving home one day. I was attracted because the tree was set almost perfectly on the horizon and the field in the foreground had been freshly ploughed and was lit in a very attractive way by the low-angled sun.

## Thinking

Because the tree was so perfectly placed and boldly silhouetted I felt that it would have more impact if I kept it quite small in the image.

## Rule of Thumb

The position of the horizon can be an important decision in landscape photography. As a general rule you should not allow it to divide the image exactly in two but place it closer to either the top or bottom of the frame.

Beside Tarn Howes – Cumbria, UK.

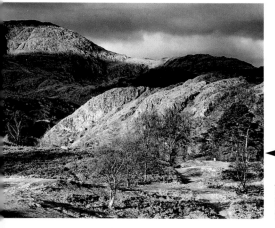

## Technical Details

6x4.5cm Single Lens Reflex – 105–210mm zoom lens, Ilford XP2.

This almost classical landscape is largely dependent upon the quality of the light for its effect. The print needed to be shaded a little to reduce the density in the darker tones but was otherwise a straight exposure on a normal grade of paper.

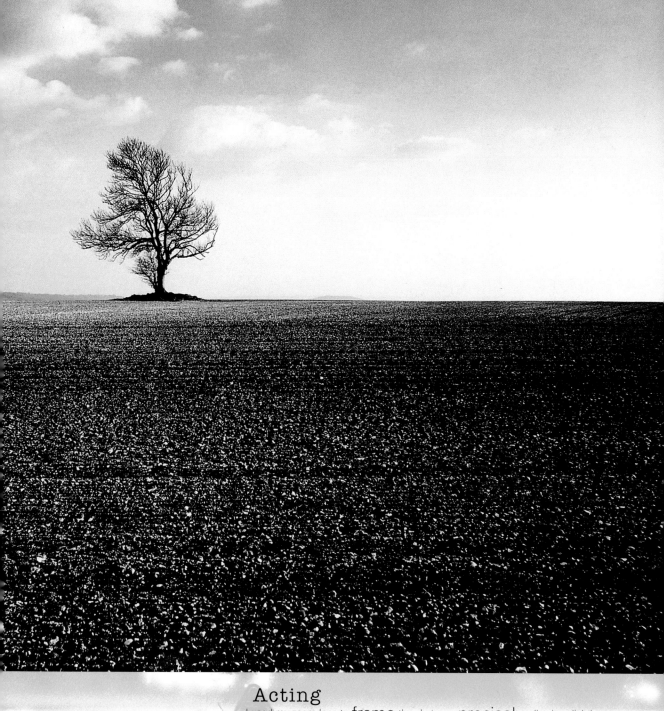

## Acting

I used my zoom lens to frame the shot very precisely, allowing slightly more space below the tree than for the sky. I also moved the tree close to the centre of the image because I didn't want it to be so obviously placed as it would have been on the intersection of thirds. I printed the negative on to a hard-grade paper to accentuate the gritty texture of the field and printed the sky in by 60 per cent.

# The Landscape

**Technical Details**
▼ 6x4.5cm Single Lens Reflex — 55–110mm zoom lens, Ilford XP2.

Technical Details
▼ 35mm Single Lens Reflex — 35–70mm zoom lens, Ilford XP2.

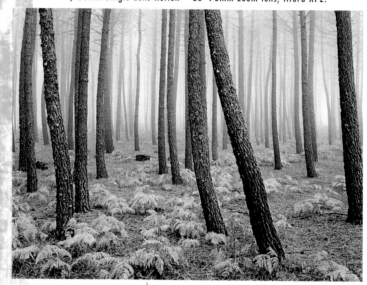

A pine forest in the Sierra de Gredos — Ávila, Spain.

This was a day of dense fog and I saw this scene appear suddenly as I drove into a clearer patch of countryside. The mist has simplified what would have been a rather fussy image. I chose the viewpoint which created the most pleasing balance and juxtaposition between the trunks of the trees and used a small aperture to ensure adequate depth of field.

## Seeing

The back lighting had created some strong divisions of tone in this scene which I felt would make a striking image.

## Thinking

I wanted the ridge of highlight along each side of the stream and the distant field to become the dominant element of the image as they would lead the eye into the picture.

## Acting

I chose a viewpoint which emphasised these details and framed the shot quite tightly, eliminating the sky which was pale and featureless. I printed the quite contrasty negative on to a normal grade of paper but exposed it to produce a range of rich, dark tones.

### Rule of Thumb

If the sky doesn't make a positive contribution to the image, and there is nothing of importance which rises above it, it is best to consider cropping it out altogether or to use the montage technique described in chapter four to add an interesting sky from another negative.

# Buildings & the Urban Environment

Although architectural photography is very different to landscape photography it, too, can be an especially satisfying subject for those working in black and white. Old buildings, whether they are churches, castles, palaces or simple cottages, invariably have a number of things in common – ancient stonework, weathered timbers and ornate decorations – while modern buildings often have clean lines, boldly contrasting materials like concrete, stainless steel and glass.

## Seeing

The contrast between the old and new building was obviously the prime reason for taking this shot.

## Thinking

I found a viewpoint from which the two buildings appeared nicely arranged together – the line of stairways were silhouetted against the lighter tones of the modern structure – and I could include the lamppost.

## Acting

As I was too close to allow the use of a shift lens, I opted to tilt the camera upwards to include the tops of the buildings and make use of the perspective effect.

**Technical Details**
6x4.5cm Single Lens Reflex – 50mm shift lens, Ilford XP2.

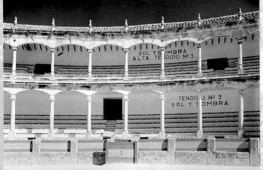

The bull ring in Rhonda – Andalucia, Spain.

I used a shift or perspective-control lens for this shot as I wanted to include less of the foreground, and tilting the camera upwards would have caused the vertical lines to converge, spoiling the effect of the elegant arcades.

### Rule of Thumb

When tilting the camera upwards for effect it's best to do so in a very positive way and to avoid including the base of the building.

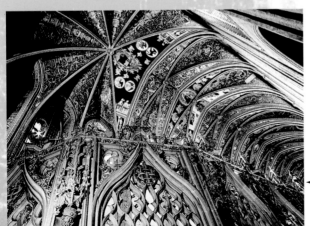

Albi cathedral – Midi Pyrenees, France.

I felt the ornate decoration of this cathedral interior would produce a richly toned black and white image. As well as tilting the camera upwards, I also tilted it sideways so the line of the roof created a diagonal, giving the composition a more dynamic quality. The print needed quite extensive shading to reduce the density of the shadows and I also needed to burn in the lighter tones near the windows.

**Technical Details**
6x4.5cm Single Lens Reflex – 50mm lens, Ilford XP2.

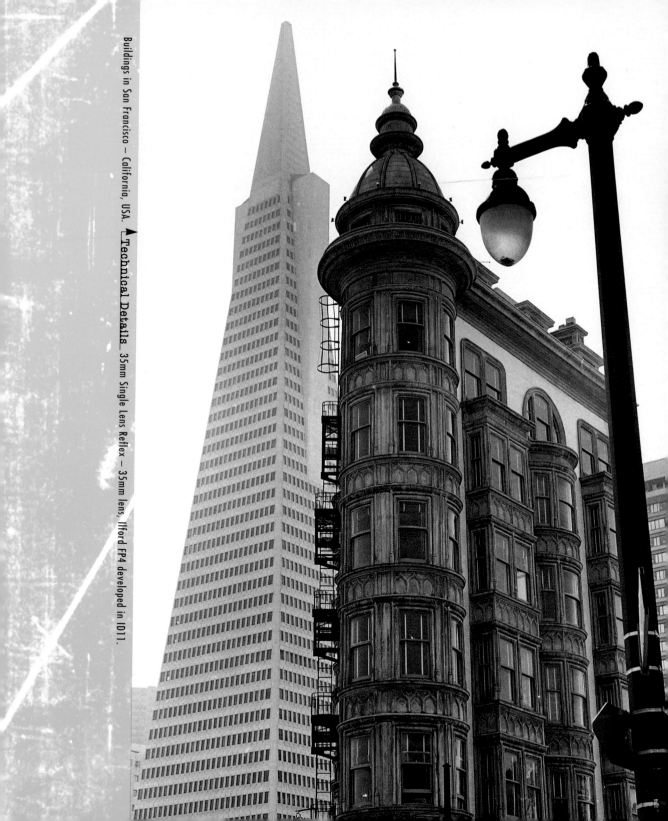

Buildings in San Francisco – California, USA. ▲Technical Details. 35mm Single Lens Reflex – 35mm lens, Ilford FP4 developed in ID11.

## Buildings & the Urban Environment

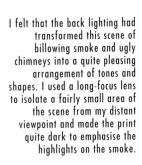

## Seeing
I was fascinated by the juxtaposition of this poster and the ship in the background but felt that it needed something else to tie it together.

## Thinking
As people were walking past I crossed the road to take up a more distant viewpoint which would allow me to include a passer-by.

## Acting
When I saw this man approaching I switched to a longer-focus lens to frame the image more tightly and waited until he reached the best spot before shooting. It was pure luck that at this point I caught him in mid stride and that he chose to look up at the poster – factors which have added to the image's impact.

I felt that the back lighting had transformed this scene of billowing smoke and ugly chimneys into a quite pleasing arrangement of tones and shapes. I used a long-focus lens to isolate a fairly small area of the scene from my distant viewpoint and made the print quite dark to emphasise the highlights on the smoke.

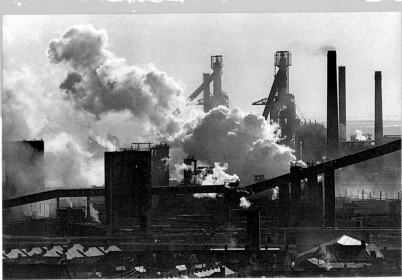

Factories near Swansea – Wales, UK.

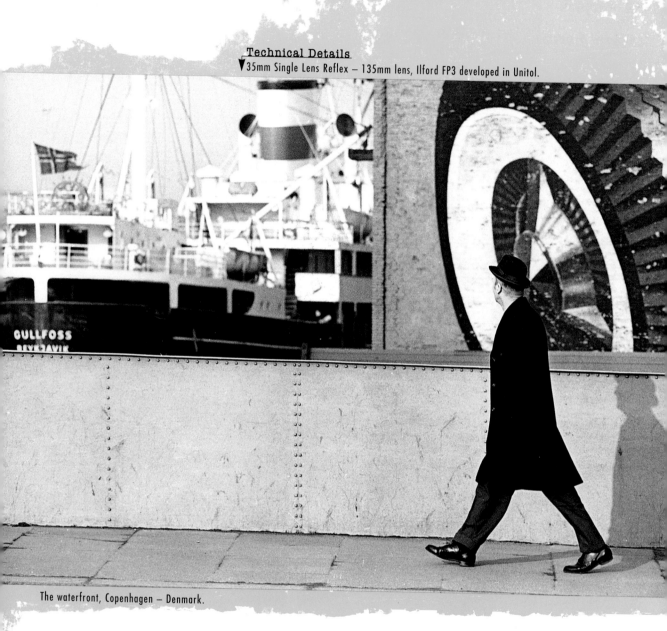

35mm Single Lens Reflex — 135mm lens, Ilford FP3 developed in Unitol.

The waterfront, Copenhagen — Denmark.

◄ Technical Details
35mm Single Lens Reflex — 200mm
lens, Ilford FP4 developed in ID11.

## Rule of Thumb

The inclusion of people in shots
of the urban landscape can not
only create a very effective focus
of interest, but can also help to
establish a sense of scale.

# Natural Forms

Of all the subjects which can be used to produce striking black and white images, perhaps the shapes and patterns created by nature are the most satisfying and interesting. Often even the most mundane objects have the potential to create powerful photographs when seen in a perceptive way.

A tor on Dartmoor — South Devon, UK.

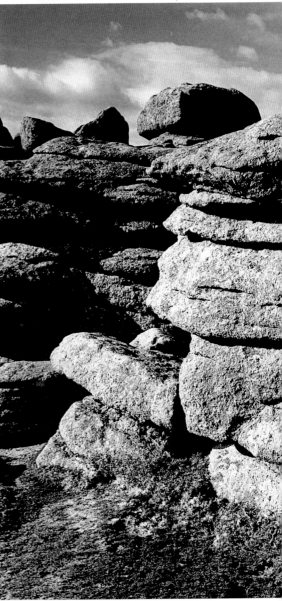

## Seeing

As a subject for black and white photographs rock formations have a very obvious **appeal** and this small tor near the roadside caught my eye as I drove by.

## Thinking

This formation was quite **complex** and I needed to find a way to simplify the image and hold it together. I noticed the strong highlight created by the late afternoon sunlight had created bold shapes and textures along the side of some of the rocks.

### Technical Details
6x7cm Single Lens Reflex — 105mm lens, Ilford FP4 developed in ID11.

I have a liking for log piles — I think it is the combination of a natural form and mans' interference which appeals. In this shot it is the pattern and texture of the sawn ends which attracted me. I used a wide aperture for shallow depth of field to give these sharply focused details clear separation from the rest of the image.

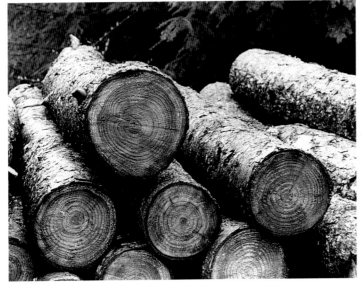

A forest near the Brecon Beacons — Wales, UK.

## Technical Details
35mm Single Lens Reflex — 24mm lens,
Ilford FP4 developed in Unitol.

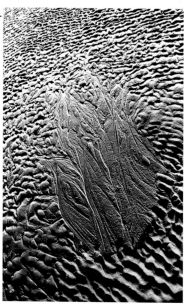

Below Brighton pier — East Sussex, UK.

Because this area of tide-washed sand was immediately below the pier and shaded from the sky, the light was angled strongly from the side and created this striking effect of form and pattern. I used a wide-angle lens so that I could shoot almost directly down from eye level and include a large area of the sand.

## Technical Details
6x4.5cm Single Lens Reflex — 55–110mm zoom lens, Ilford XP2.

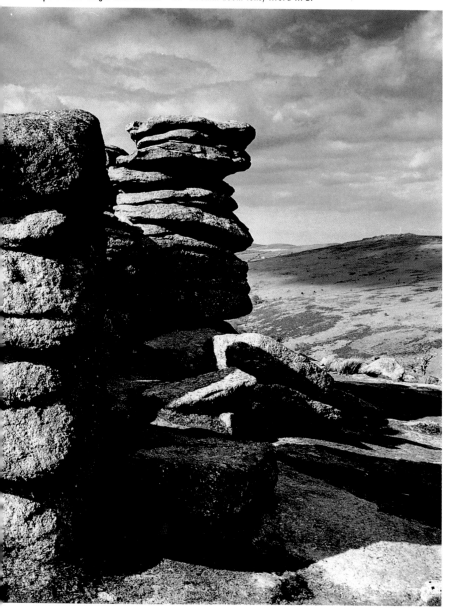

## Acting
I chose a viewpoint which placed the most dominant contrasts in the foreground and also allowed the shadows on a second, more distant formation to be silhouetted against the sky. I used my zoom lens to frame the image so that a small area of shaded rocks was included on the left of the image and some of the distant landscape was visible on the right.

# The Portrait – Using Daylight

In spite of the fact that books and magazines are now printed largely in colour, it's true to say that the vast majority of creative portrait photography is still produced in black and white and it remains the favoured medium of many leading photographers in this field. The human face has a very strong visual appeal and when combined with the use of sensitive lighting and the ability to capture fleeting and significant expressions, the resulting images can be among the most compelling of all when they also have a rich photographic quality.

## Rule of Thumb

Eye contact can be a powerful element of portrait photographs and while shooting unobserved can sometimes create a more natural and spontaneous image, it can often be more effective to shoot when the subject's aware of the camera and looking into it.

This man was less comfortable with the camera, although very willing to have his photograph taken. I liked the effect of the sunlight on his weathered skin and chose a viewpoint from where it created the most pleasing effect, with a minimum of shadow.

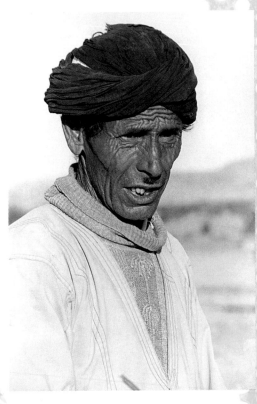

A farmer near Taroudant – Morocco. ▼ 35mm Single Lens Reflex – 105mm lens, Ilford XP1. **Technical Details**

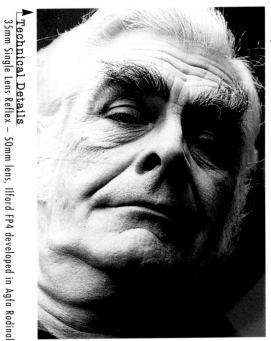

▲ **Technical Details** 35mm Single Lens Reflex – 50mm lens, Ilford FP4 developed in Agfa Rodinal.

The subject's home.

## Seeing

I spotted this young lad carrying fish from a boat to be laid out in the sun to dry and felt sure I might get an **appealing picture** from the situation.

## Thinking

It was obvious that I was very **unlikely** to be able to shoot **unobserved** and decided to simply ask him to pose for me. This is always a gamble as many people tense up and you lose the natural, **spontaneous** quality which attracted you in the first place.

A Beach near Negombo – Sri Lanka.

▼ **Technical Details**
35mm Single Lens Reflex – 35–70mm zoom lens, Ilford XP1.

## Acting

Happily this young man was
a **natural**. I asked him
to stand with the sea
behind him as a plain
background and to allow
the sunlight to light his face
with only a small amount of
shadow. I framed the shot
to include his basket of
fish.

## Rule of Thumb

As a general rule, a viewpoint slightly above the model's eye level creates the most flattering effect and this is invariably enhanced by having the face at a three-quarter angle rather than full on.

## Seeing

I had arranged to photograph these two models for their portfolios and among the clothes the girl had brought with her was this leather jacket and trousers.

## Thinking

I thought that it might be effective to photograph them together but in a way which made the black leather the dominant feature of the shot.

## Acting

I chose a white background to provide a bold contrast to the black leather and asked the young man to stand behind the girl. He contributed the slightly suggestive pose, which I thought added a suitably punkish note to the image. I lit them by placing a sheet of white polystyrene at an angle at their feet and bounced a single flash from it so that it directed a soft light up under their chins, creating a rather gentler version of the Hammer Horror movie lighting, for a subtly sinister effect.

This portrait of yours truly by my son Julien was lit by a single diffused light almost at right angles to me. He used a black screen on the opposite side to prevent reflected light being bounced back into the shadows as he wanted them to be black. The background was a piece of hand-painted canvas thrown out of focus.

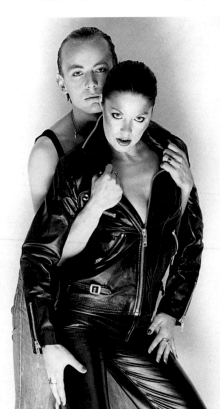

The Studio. ▲Technical Details
35mm Single Lens Reflex – 50mm lens, Ilford XP1.

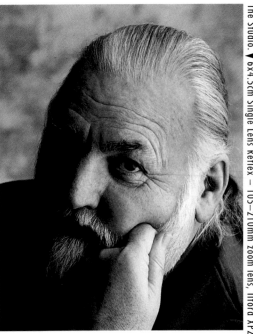

The Studio. ▼Technical Details
6x4.5cm Single Lens Reflex – 105–210mm zoom lens, Ilford XP2.

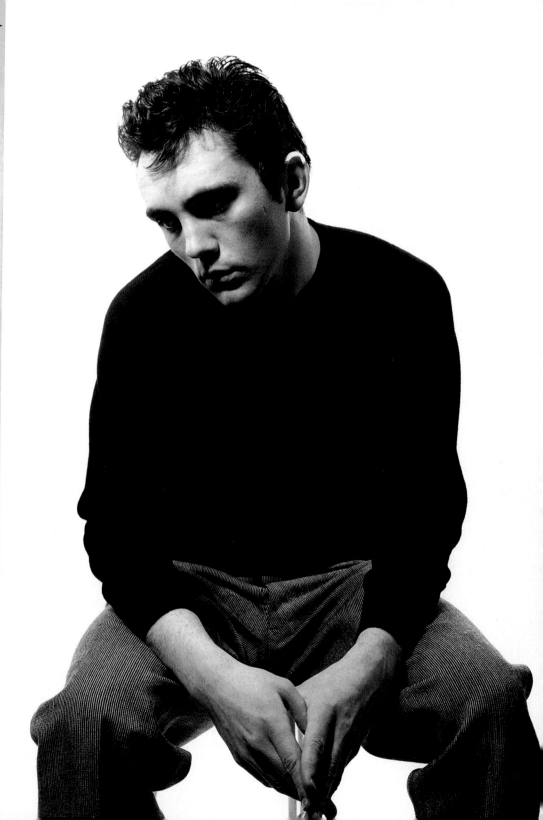

**Technical Details** 6x6cm Twin Lens Reflex — 75mm lens, Ilford FP3 developed in ID11

The Studio.

I lit this portrait of the young Terence Stamp using a single undiffused light slightly to the left of the camera. The background of white paper was lit by two lights aimed at it from just behind him and the one on the right was allowed to spill a little on to the side of his face to create a highlight.

# The Nude – Using Daylight

It could be said that, in photographic terms, the landscape and the human body have much in common, especially when photographed in black and white. They both have similar potential for creating images with a rich range of tones, a strong impression of form and perspective and bold textures. The medium of black and white also has the ability of firmly distancing an image from the very commercial, and much less creative, field of glamour photography, in which titillation is the main criteria.

## Seeing

It was the setting which inspired this shot. I discovered a deserted farmhouse which had good daylight flooding through the window and I thought the white plaster wall and old ceiling beams would make a good foil for a nude photograph.

## Thinking

I asked the model to adopt this rather coy pose and the slightly miserable expression to emphasise the rather ambiguous nature of the set up as well as avoiding eye contact with the camera as this would have made the picture too personal for my purposes.

## Acting

I chose a viewpoint which, using a standard lens, allowed me to include a lot of space around the model with the intention of heightening the sense of 'What is she doing there?' and framed the shot so that her head was pretty well in the centre of the image.

An old farmhouse near Carvoeiro – Portugal. **Technical Details** 6x6cm Single Lens Reflex – 80mm lens, Ilford XP1.

A beach on Formentera – Balearic Isles, Spain.

Beaches and nudes go together very well as, unlike the previous image, it seems a quite natural setting in which to be without clothes. In order to avoid the image seeming too much like an illustration for a naturist magazine, I asked the model to adopt this rather strained pose and shot from a low angle to accentuate it.

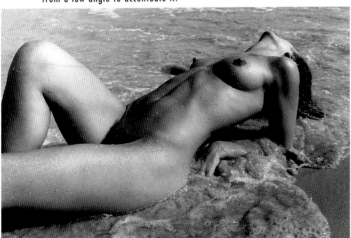

**Technical Details** 6x6cm Single Lens Reflex – 80mm lens, Ilford XP2.

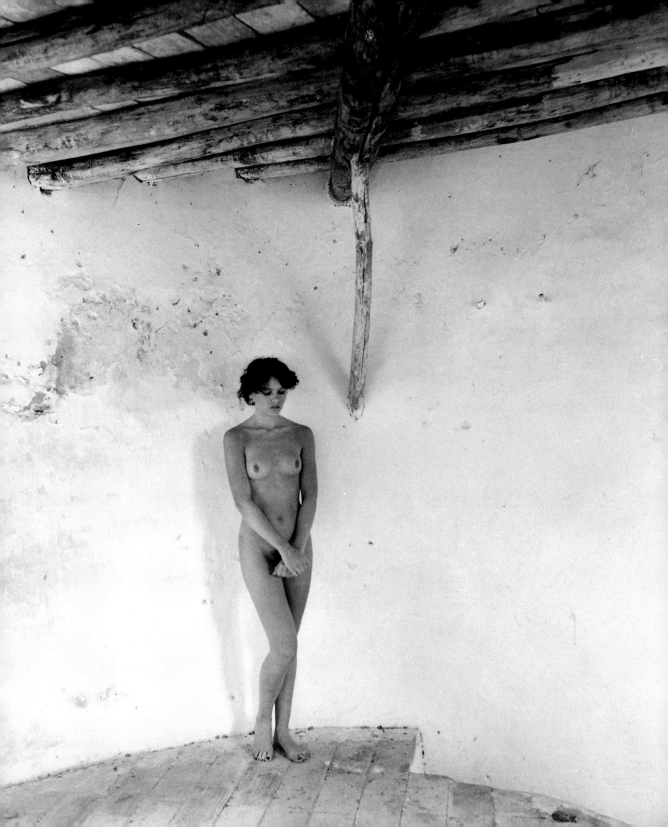

# The Nude – The Studio

## Seeing

It was the old-fashioned stool which acted as the trigger for this shot as it suggested the model's pose, as well as being an interesting prop.

## Acting

I lit her very simply with a single, diffused light from almost right-angles to the camera and used a black screen to prevent any light being bounced back and weakening the shadows.

## Thinking

I wanted to make the model's finely-shaped back the feature of this shot, so I set her against a plain, dark background. I asked her to turn her head to the shadowed side to create a more interesting shape but at the same time keeping the image impersonal.

Home Studio.

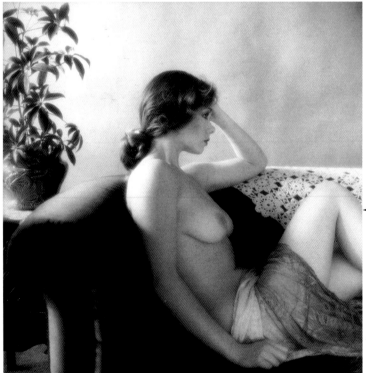

### Rule of Thumb

If you don't have a friend or relative who is willing to be a model for nude photography there are a variety of other possible sources. Most major cities have model agencies with files of index cards of suitable people. Although model fees are normally expensive, newcomers to the profession are often willing to model for a lower rate – or for free – in order to obtain images for his or her portfolio. Art colleges usually have access to amateur models for their life classes.

### Technical Details

6x6cm Single Lens Reflex– 80mm lens, Zeiss Softar, Ilford XP2.

This nude was an attempt to create a slightly romantic image with a Victorian feel – hence the hairstyle and the added props of a lace coverlet and a pot plant. It was set up in my sitting room and the illumination was from a large window at right-angles to the left of the model. I placed a large sheet of white polystyrene immediately in front of her to bounce light back into the shadows and I used a soft-focus attachment to heighten the romantic mood. A roll of white paper was draped down behind her to create a plain background tone.

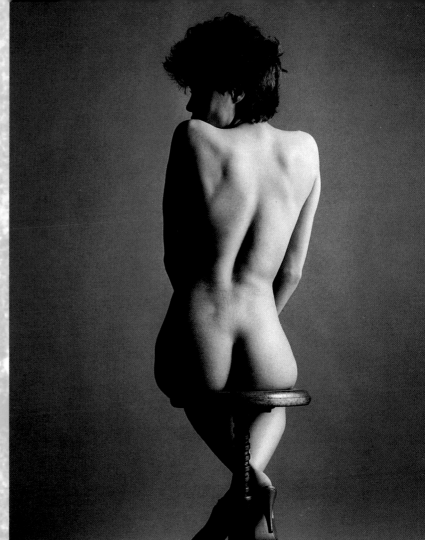

The Studio.

This very straightforward nude torso relies for its appeal on the image quality of the model's skin. It was lit very simply with a single, slightly-diffused light from just to the right of the camera. Two additional lights were placed behind him to illuminate a roll of white background paper and a black screen was placed close to him on the left hand side to keep the shadows black.

▲Technical Details
6x6cm Single Lens Reflex – 150mm lens, Ilford XP2.

The Studio.

▲Technical Details
6x6cm Single Lens Reflex – 80mm lens, Ilford XP2.

# The Nude – The Abstract Approach

As with other natural forms, like rocks and trees, the human body lends itself very well to a more abstract approach where the subject is of less importance than the effect it creates and becomes simply a vehicle for interesting lighting, the use of unusual viewpoints and creative framing.

## Seeing

This old farmhouse offered numerous possibilities as a background and location. In this picture I was taken by the relationship between the black window cavity and the strongly patterned roof.

## Thinking

This small section of the old farm seemed interesting enough to have produced a satisfying image on its own but the temptation to place something inside the window was too great to ignore.

## Acting

I asked the model to go inside the building and experiment with poses within the frame of the window. She moved into a variety of positions, many of which worked very well, but I liked this most of all as the diagonal line of her body created such a strong contrast with the otherwise exclusively parallel lines in the image. I framed the shot so that the base of the building was just visible, all of the roof was included and the window was just slightly off centre.

## Rule of Thumb

When shooting nudes remember to ask your model to remove any tight clothing at least an hour before you are ready to shoot to avoid marks, and use make-up to mask any skin blemishes – these will show up more strongly on film than appears visually.

This nude torso was lit very simply. Two lights were aimed at a white background placed about four metres behind the model. The only illumination on her body is that which is reflected from the background because I wanted the image to be almost pure silhouette. The model was leaning back on to a table and I tilted the camera sideways to produce this diagonal framing.

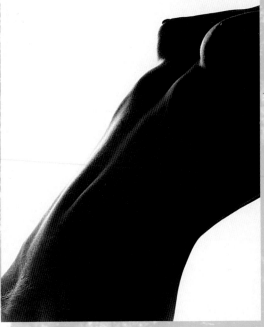

A deserted farmhouse near Carvoeiro – Portugal. ▲ **Technical Details** 6x6cm Single Lens Reflex – 150mm lens, Ilford XP2.

The Studio. ▼ **Technical Details** 6x6cm Single Lens Reflex – 150mm lens, Ilford XP2.

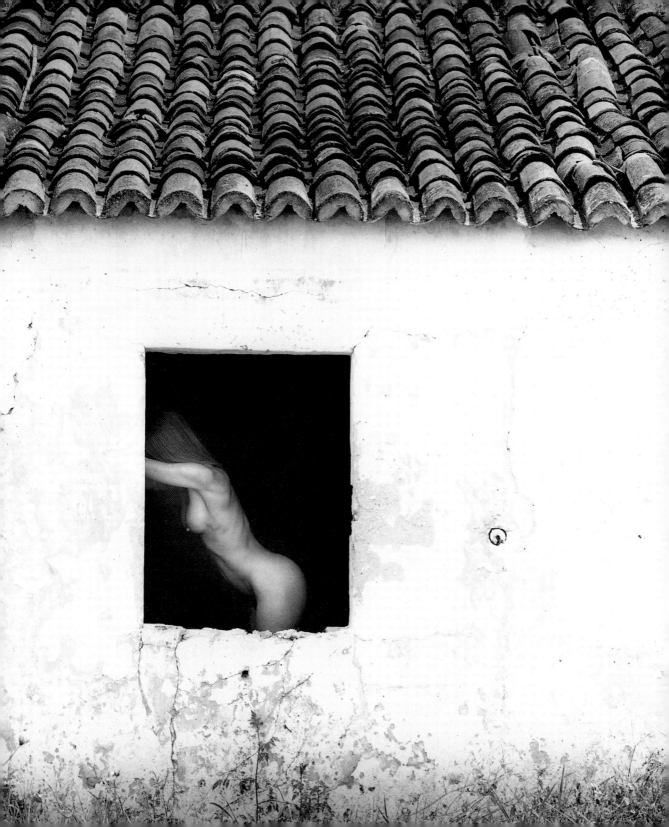

## Still–life Photography

Still-life photography allows a photographer to become as close as possible to having the creative control which painters are able to employ with paints and canvas. Each element of a still-life arrangement can be selected to create a particular effect and they can be arranged and rearranged until you achieve exactly the composition you want.

### Seeing

Julien Busselle made this image as an illustration for a cookery book. He saw the similarity in tone and texture between the window frame and the pears and arranged them using the right-angle shape in the corner of the window as a support.

### Thinking

The light from the window created quite strong shadows within the pears and because Julien wanted the image to have a light, silvery quality he placed a large white reflector very close to the pear to bounce light back and weaken the shadows.

### Acting

The background was a textured exterior wall and Julien found that by controlling the depth of field – by his choice of aperture – he could use it to create a soft, dappled pattern which would contribute to the silvery effect. The print was made on a soft-grade paper with just enough exposure to create the subtle, mid-grey tone the pears needed to be.

### Rule of Thumb

Taking still-life pictures provides perhaps the best way of learning how to control the medium of black and white and offers an excellent method of discovering the ways in which a subject can be lit and composed most effectively.

**Technical Details**
▼ 6x6cm Twin Lens Reflex – 75mm lens, Ilford FP3 developed in Unitol.

rue Mouffetard, Paris – France.

Still-life photographs do not necessarily have to be constructed. This one was found ready-made in a Paris street market and it simply needed to be framed tightly to exclude unwanted details.

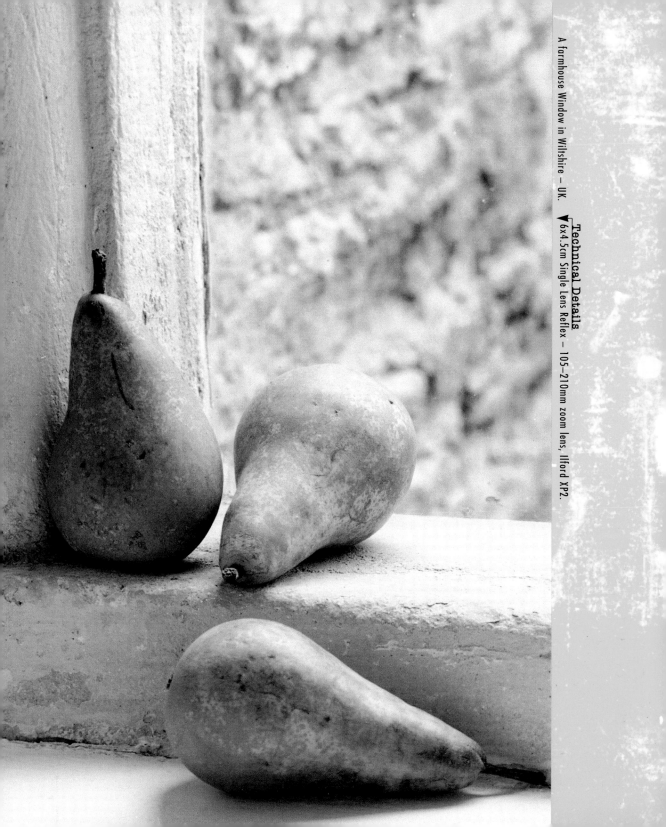

**Technical Details**
▼ 6x4.5cm Single Lens Reflex — 105–210mm zoom lens, Ilford XP2.

A farmhouse Window in Wiltshire — UK.

## Close-up Photography

Moving much closer to quite ordinary subjects can often reveal details of astonishing beauty. Close-up photography can make a textured surface seem as big and important as a landscape and create shapes and patterns in everyday objects which would otherwise not be visible.

## Seeing

A hard overnight frost had coated the floor of this wood with a magical layer of icing. I noticed this small leaf which had been frozen to the trunk of a fallen tree and which almost seemed to be camouflaged.

## Thinking

I thought it was the textural effect the frost had created which would be the most powerful aspect of the photograph and although I was tempted to have a much closer image of the leaf I felt that the overall impact would be greater if I included more of the bark and let the leaf become nearly hidden within it.

## Acting

I used an extension tube in conjunction with my zoom lens to frame the image the way I felt it would be most effective, including the diagonal line in the bark and placing the leaf, also on a diagonal, just off centre. I printed the negative on to a hard-grade paper to accentuate the texture.

### Rule of Thumb

Depth of field becomes increasingly restricted as the lens is focused at closer distances and it is necessary to use a small aperture for subjects where you want to have the image sharp overall, especially if they are not flat on to the camera.

### Technical Details

35mm Single Lens Reflex – 75–150mm zoom lens, extension tube, Ilford FP4 developed in ID11.

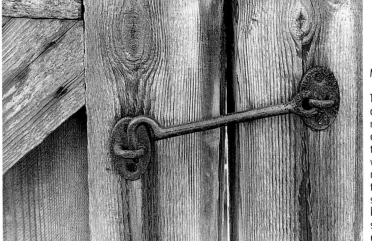

My garden gate.

This picture depends upon two main things for its effect: the rich texture of the woodgrain and rusty hook together with the strong downward lines of the panels set against the angled hook.

# Technique

Most cameras have lenses which will only focus down to a couple of metres or so but for close-up photography it's often necessary to focus at much closer distances. **Extension tubes** or a **bellows** unit can be fitted between an SLR camera body and a normal lens to accomplish this, but a macro lens can be a good investment for those interested in producing this type of image as it can create a **life-size image** of a subject on the film.

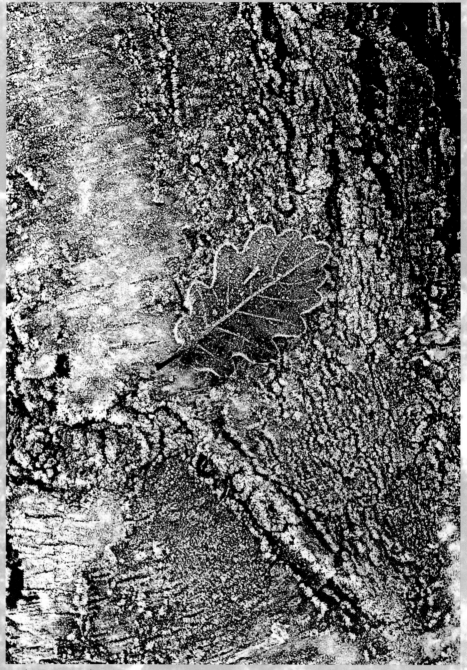

Woods near Sevenoaks — Kent, UK.

▲ Technical Details
6x4.5cm Single Lens Reflex — 105–210mm zoom lens, extension tube, Ilford XP2.

# Documentary Photography

Almost from its birth, over 150 years ago, photography has played a central role in documenting our society with its wars, customs, events and celebrations. Even though colour film has now become standard for most journalism and documentary work, some of the finest practitioners today, such as Sebastian Salgado and Don McCullin, still favour the unique qualities of black and white.

## Seeing

When the fishing boats go out from this beach they carry with them a net which is dropped at sea and left for those on the beach to pull in. It's a stirring sight and the effort involved is considerable.

## Thinking

I wanted to capture the mood of this activity and felt that my best approach was to show as much of the scene as possible while ensuring the image had a strong focus of attention.

The beach at Nazare – Portugal.

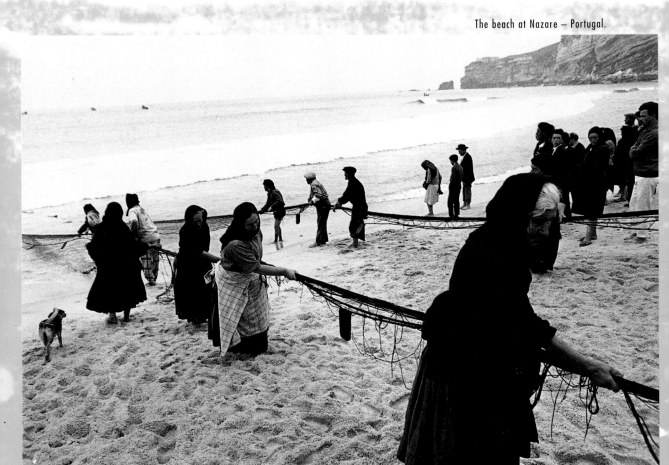

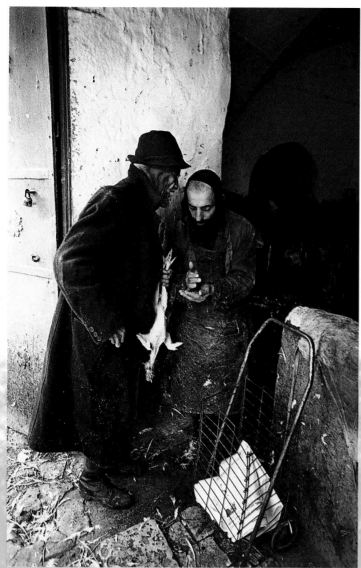

The Orthodox Quarter –
Jerusalem, Israel.

I had watched the activities of this
shop for a while from some
distance away and was waiting for
an opportunity to take a picture.
When I saw that this transaction
was about to take place I moved
quickly to a closer viewpoint with
my camera ready set and pre-
focused and was able to make my
exposure at the moment the money
and goods changed hands.

## Acting

I decided to use a close viewpoint and waited until this lady, clad
in black, moved into the foreground before shooting. I used a
**wide-angle lens** to include a large area of the scene
and to exaggerate the perspective, which has helped to create a
more **dynamic** composition.

### Technical Details
35mm Single Lens Reflex– 35mm lens, Kodak Tri X developed in Unitol.

### Technical Details
35mm Single Lens Reflex – 28mm lens, Kodak Tri X developed in D76.

# Documentary Photography

## Seeing

I noticed this elderly lady pushing her bicycle through the park and had been **stalking** her with the intention of shooting a picture.

## Thinking

My opportunity arose when she parked her bike and began to feed the pigeons.

## Acting

I moved further away on to a slight rise in the ground which enabled me to shoot down and show more of the birds and the surroundings. From this more distant viewpoint I needed to use a long-focus lens to **exclude unwanted details** and framed the shot so that the lady and the bike were more or less in the **centre** of the image.

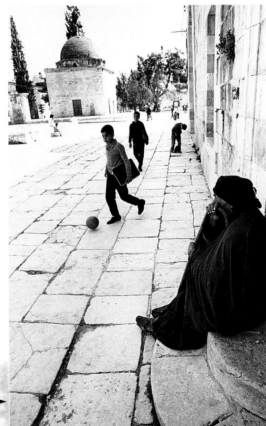

The Old City, Jerusalem – Israel.

I chose a viewpoint which enabled me to place this old man in the near foreground and I used a · wide–angle lens to include a large area of the background. I waited until the child with the football moved into the best position before making my exposure.

**Technical Details**
35mm Single Lens Reflex – 28mm lens, Ilford FP3 developed in Unitol.

## Technique

One particular aspect of documentary photography which can provide a different and challenging approach is the opportunity of seeing images as part of a series rather than regarding them as quite separate individual photographs. A documentary project can encourage a photographer to build up a body of work in which each image is an integral part of a whole collection and this can be an ideal platform from which to mount an exhibition or establish a portfolio.

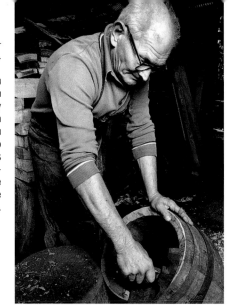

A Cooper's workshop — Wiltshire, UK.

This shot, showing a cooper finishing off a barrel, was taken by the light from an open doorway. I chose a fairly close viewpoint to help show his actions clearly and used a wide-angle lens to allow the inclusion of all the important details.

Technical Details ▶
35mm Single Lens Reflex - 35mm lens, Kodak Tri X developed in D76.

Technical Details
▼ 35mm Single Lens Reflex — 135mm lens, Ilford FP3 developed in Unitol.

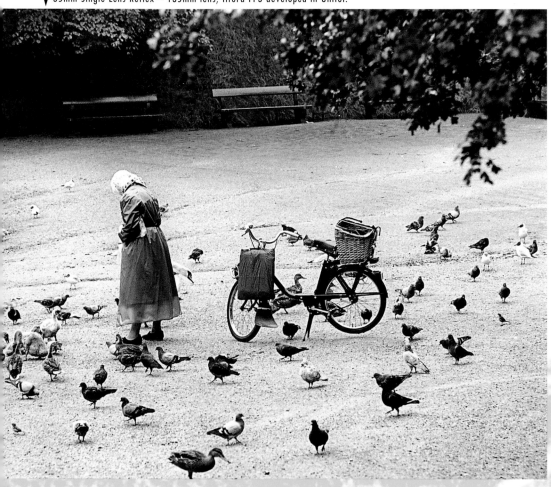

A Park in Copenhagen — Denmark

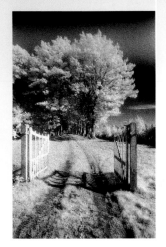

The Camera

3

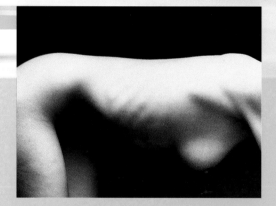

In common with all crafts, choosing the right tools for photography can make a
big difference, both to the ease of working and to the results achieved. Choosing the right
equipment and understanding how to use it is the first step.

# Camera Types

The choice of camera, type and format for black and white photography depends upon a number of factors. Versatility is perhaps one of the most important factors as black and white photography covers all subject types.

## Format and image size is the most basic

consideration. The image area of a 35mm camera is approximately 24x36mm but with roll - film it can be anything from 45x60mm up to 90x60mm according to camera choice. The degree of enlargement needed to provide, say, an A4 reproduction, is much less for a roll - film format than for 35mm and gives a potentially higher image quality.
For most photographers the choice is between 35mm and 120 roll - film cameras. The Advanced Photo System offers a format slightly smaller than 35mm and for images larger than 60x90mm it is necessary to use a view camera of 5x4in or 10x8in format.

## Pros & cons

APS cameras have a more limited choice of film types and accessories and are designed primarily for the use of colour negative film. 35mm Single Lens Reflex cameras are provided with the widest range of film types and accessories and provide the best compromise between image quality, size, weight and cost of equipment. Both accessories and film costs are significantly more expensive with roll - film cameras and the range of lenses and accessories more limited than with 35mm equipment. Facilities such as autofocus and motor drive are available on very few roll - film cameras and these cameras are also generally heavier and bulkier than 35mm cameras. View cameras provide extensive perspective and depth of field control and are especially useful for architectural and still-life photography but are cumbersome and not user-friendly.

Choice of camera format is also dependent upon the subject matter and the style of photography and for reportage photographs of this type I prefer to use 35mm.

This shows the relative sizes of the 35mm, 6x7cm and 5x4in formats.

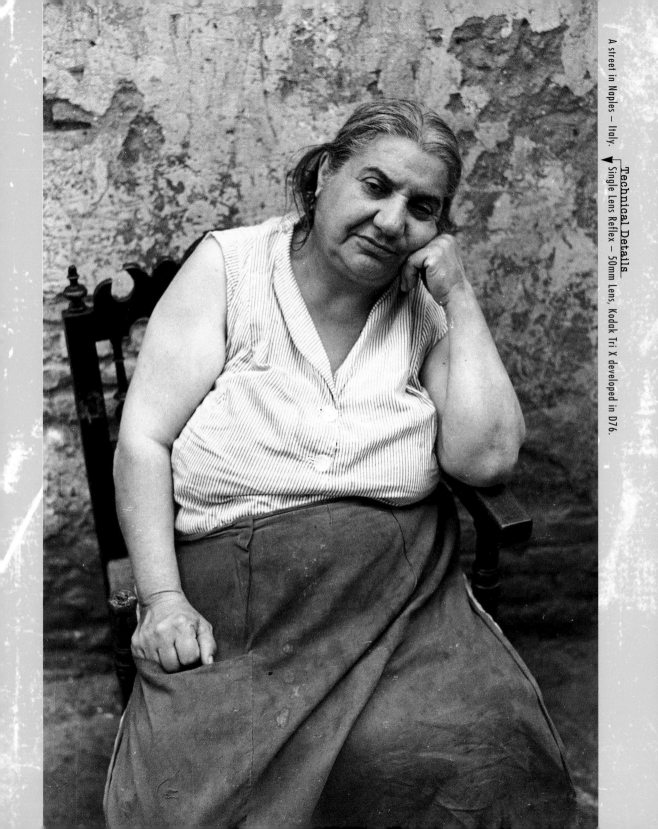

**Technical Details** ◀
Single Lens Reflex – 50mm Lens, Kodak Tri X developed in D76.

## Camera Types

There are two basic choices between both roll - film and 35mm cameras: the Viewfinder Camera and the Single Lens Reflex (SLR).

## Pros & cons

The SLR allows you to view the actual image which is being recorded on the film while the viewfinder camera uses a separate optical system. The effect of focusing can be seen on the screen of an SLR but the whole image appears in focus when seen through a viewfinder camera. Generally, facilities like autofocus and exposure control are more accurate and convenient with SLR cameras and you can see the effect of filters and attachments with the latter. SLR cameras have a much wider range of accessories and lenses available to them, and are more suited to subjects like wildlife needing very long-focus lenses and close-ups. Viewfinder cameras tend to be lighter and quieter than SLRs.

## Specialist Cameras

While it's possible to produce panoramic format photographs with some ordinary 35mm and roll-film cameras, dedicated 6x12, 6x17 and 6x24cms cameras are the best way of creating true panoramic images and with the large negative size are capable of producing black and white prints of very high quality. These are essentially viewfinder cameras taking 120 roll - film with a greatly elongated film chamber. Some have fixed wide-angle lenses while others have interchangeable lenses. An alternative to using a dedicated panoramic camera is to use a 6x12cm roll-film back with a 5x4in view camera.
In addition to conventional panoramic cameras there are also swing-lens cameras, such as the Widelux, giving a panoramic image over a wide angle of view. These can be bought in both 35mm and 120 roll - film formats and have a moving lens mount which progressively exposes the film. This gives a more limited range of shutter speeds and also causes horizontal lines to curve if the camera is not held completely level.

I used a medium-format camera for this shot to maximise image quality and reduce the effect of grain. A single diffused light was placed almost at right-angles to the model with a black screen on the opposite side to stop light being reflected back into the shadows as I wanted them to remain black.

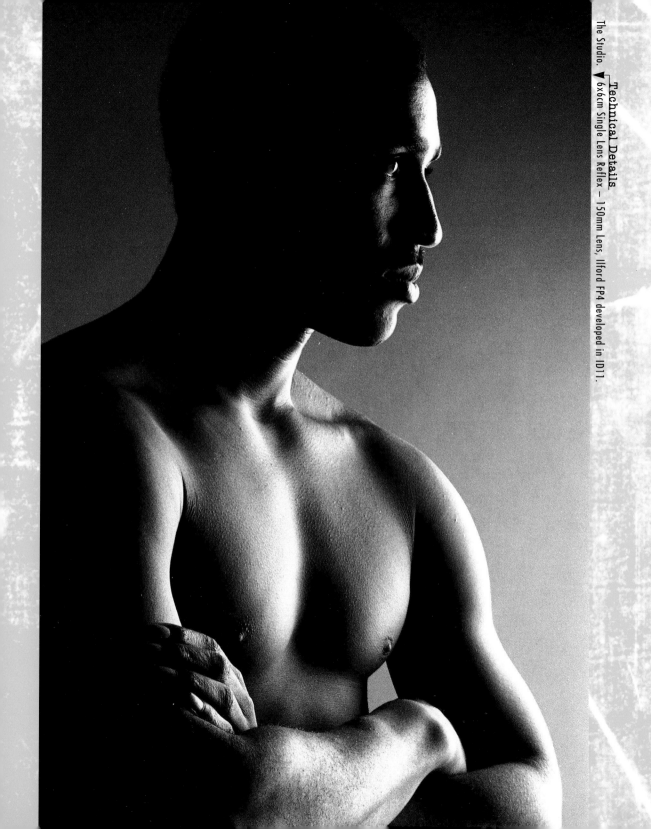

**Technical Details**
The Studio. ▼ 6x6cm Single Lens Reflex – 150mm Lens, Ilford FP4 developed in ID11.

# Choosing Lenses

A standard lens is one which creates a field of view of about 45 degrees and has a focal length equivalent to the diagonal measurement of the film format in use ie. 50mm with a 35mm camera and 80mm with a 6x6cm camera. Lenses with a shorter focal length create a wider field of view and those with a longer focal length produce a narrower field of view. Zoom lenses provide a wide range of focal lengths within a single optic, taking up less space and offering more convenience than having several fixed lenses.

## Pros & cons

Many ordinary zooms have a maximum aperture of f5.6 or smaller. This can be quite restricting when fast shutter speeds are needed in low light levels and a fixed focal-length lens with a wider maximum aperture of f2.8 or f4 can sometimes be a better choice.

Zoom lenses are available for most 35mm SLR cameras over a wide range of focal lengths but it's important to appreciate that the image quality will drop with lenses which are designed to cover more than about a three-to-one ratio, ie. 28–85mm or 70–210mm.

## Special Lenses

For subjects like sports, a lens of more than 300mm will often be necessary while one between 400–600mm is useful to obtain close-up images of action – in a sports' stadium, for example. For those interested in architecture a perspective-control or shift lens can be a good investment. These allow the lens to be physically moved from its axis to allow the image to be moved higher or lower in the frame without the need to tilt the camera, thereby avoiding the converging verticals which this produces.

Hythe pier – Kent, UK.

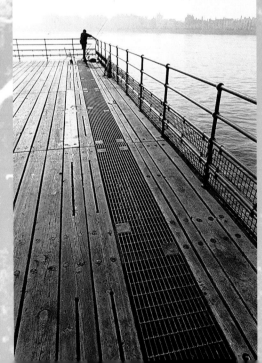

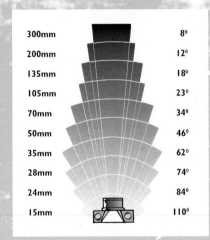

| | | |
|---|---|---|
| 300mm | | 8° |
| 200mm | | 12° |
| 135mm | | 18° |
| 105mm | | 23° |
| 70mm | | 34° |
| 50mm | | 46° |
| 35mm | | 62° |
| 28mm | | 74° |
| 24mm | | 84° |
| 15mm | | 110° |

This illustration shows the varying fields of view for different focal length lenses used with a 35mm camera.

I used a very wide angle lens for this shot to include close foreground details and to exaggerate the perspective.

◄ Technical Details
35mm Single Lens Reflex – 20mm lens, Ilford FP4 developed in Unitol.

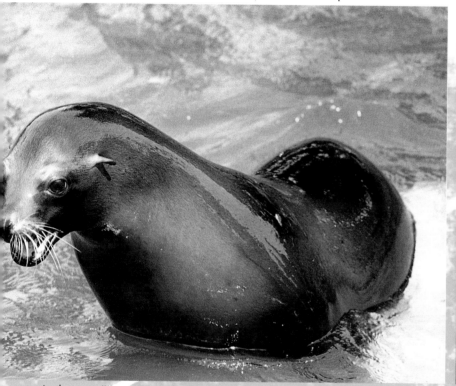

London zoo — UK.

I used a long-focus lens to frame this shot of a seal tightly from a fairly distant viewpoint.

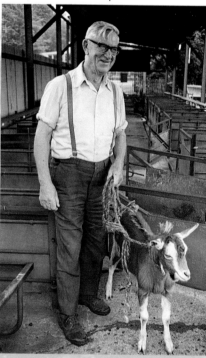

Sevenoaks market — Kent, UK.

A standard lens framed this image in the way I wanted from my chosen viewpoint.

A macro lens is also very useful for those specialising in close-up images of subjects like flowers, making it possible to obtain life-size images without the need for extension tubes or close-up attachments.

Extenders can allow you to increase the focal length of an existing lens: a x 1.4 extender will turn a 200mm lens into 300mm and a x2 extender will make it 400mm. There will be some loss of sharpness with all but the most expensive optics and a reduction in maximum aperture of one and two stops respectively.

# Camera Accessories

There is a wide range of accessories which can be used to control the image and increase the camera's capability. Extension tubes, bellows units and dioptre lenses will all allow the lens to be focused at a closer distance than it's designed for and this can be useful, not only for obvious close-up subjects like, say, flowers, but also to allow tightly cropped portraits to be shot when the lens in use only focuses down to a couple of metres.

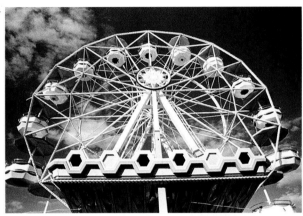

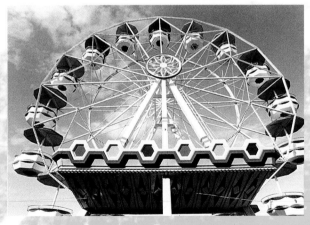

▲Technical Details
35mm Single Lens Reflex – 20mm lens, Ilofd FP4 developed in ID11.

# Filters

A selection of filters will help to extend the degree of control over the tonal range of a black and white image and a **square filter system**, such as Cokin or HiTech, is by far the most convenient and practical option. These allow the same filters to be used with all your lenses regardless of the size of the lens mounts as each can be fitted with an adaptor upon which the filter holder itself can be easily slipped on and off.

A **polarising filter** is extremely useful for reducing the brightness of reflections in non-metallic surfaces and will also make a blue sky record as a darker grey, creating greater relief with white clouds. Polarisers are available in either **linear** or **circular** form. The former can interfere with some auto-focusing and exposure systems – your camera's instruction book should tell you, but if in doubt use a circular polariser.

Perhaps one of the most important accessories is a **tripod** as it can greatly improve image sharpness and allow you to shoot pictures in low-light levels where hand-held shutter speeds are not possible. It's best to buy the most substantial one you feel able to carry comfortably as a very lightweight tripod can be of very limited usefulness. A shake-free means of firing the camera, such as a **cable release** or a **remote trigger**, is advisable when using a tripod-mounted camera.

Brighton pier - East Sussex, UK.

These two images show the effect of an orange filter which has been used to darken the sky considerably when compared with the unfiltered picture.

# Technique

A selection of **colour contrast** filters is also very useful as they can be used with black-and-white film to manipulate the **tonal range** of an image. The basic principle is quite simple. Filters of the three primary colours of red, green and blue will make objects of their **own colour** in a subject **lighter in tone** and the opposite colours darker.

It's easy to understand if you consider an arrangement of red roses with green leaves on a blue background, for instance. When photographed **without a filter** the tones of the blooms, the leaves and the background would be very **similar** – a mid grey. But if a dense red filter was used, the red blooms would record as **near white** while the leaves and background would be close to **black**. With a green filter the green leaves would appear as a very light tone and the roses and background as very dark tones. With a pure blue filter the background would be almost white and the roses and leaves almost black. In practice, weaker-tinted filters, such as yellow and orange are generally used to create more **subtle** effects.

## Technical Details

▼ 6x6cm Single Lens Reflex – 150mm lens with extension tube, Ilford XP1.

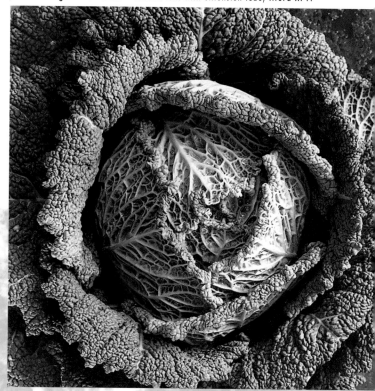

The Studio.

An extension tube was necessary to allow the lens to focus closely enough to produce this tightly cropped image of a cabbage.

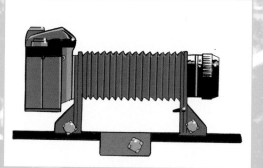

This illustration shows a bellows unit attached to a 35mm SLR camera.

# Lighting Equipment

Although many cameras now have a built-in flash, these are usually of restricted power and a separate flash gun can be a very useful accessory. It will be much more powerful than one built in and it can be used off camera, fitted with a diffuser and used to bounce light from a ceiling. It's best to buy the most powerful which size and budget will allow.

For those who's interest lies in subjects like portraiture, nudes and still lifes a modest range of studio lighting equipment will greatly increase the effects you can achieve with a simple flash gun. Although a small flash gun is a useful accessory it has limited use in these fields as you can't judge the effect before taking your photographs.

At relatively modest cost it is possible to but, two or three photoflood or tungsten halogen lights with a variety of reflectors and stands which will allow you to create a wide range of effects. In addition to the normal dish reflectors you will also need a means of creating a diffused light.

An umbrella reflector, or soft box, is ideal but you can also make a simple diffusing screen using a wooden frame covered with tracing paper. A couple of white fill-in reflectors are also invaluable – large sheets of inch-thick polystyrene, available from DIY stores, are ideal, but you will also find a variety of collapsible ones, such as Lastolite, in most photographic stores.

Studio-type flash equipment can be preferable to tungsten lights when photographing people because the brief duration of the flash ensures a lack of subject movement. The mono-block system is ideal for such purposes. These have the flash generator, flash tubes and a modelling light built into a single small unit. One is connected by a synchronising lead to the camera and the others are fired simultaneously by a slave cell. You can use the camera's built-in metering system when using tungsten lighting but for flash lighting you will need to buy a special, separate flash meter.

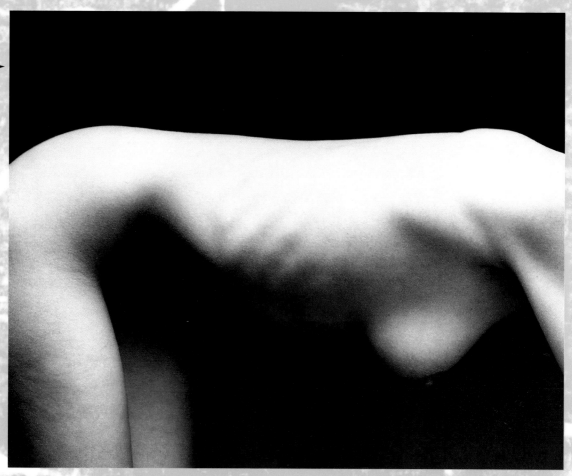

A diffused light suspended from a boom stand and aimed from directly above the model created the effect in this nude photograph. A black background was chosen to emphasise the dramatic quality of the image.

This illustration shows the set-up for the picture above.

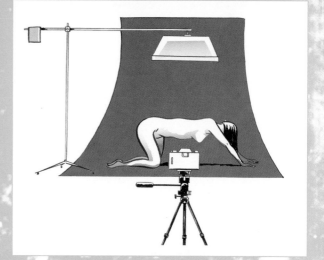

There is a huge variety of film types and speeds from which to choose
and although, to a degree, it is dependent on personal taste there are
some basic considerations to be made.

## Special Films

In addition to a wide range of films of varying speeds there are also special-purpose films which can be used to produce a variety of creative effects.

Kodak's 2475 recording film can produce a very pronounced, almost crystalline, grain structure which can look very effective with subjects such as landscapes, nudes and documentary photography.

Ilford's XP2 and Kodak's T Max T400 CN are black-and-white films based on colour negative technology and can be processed in standard colour negative chemistry with prints produced by the one-hour photo labs. These usually have a slightly sepia tint but the negatives can also be printed on normal black-and-white papers.

These films have a wide exposure latitude around the stated speed of ISO 400 and produce a very high-quality image with minimal grain, providing an excellent option for beginners and for those who don't wish to process their own films.

Agfa's Scala is a process-paid black-and-white transparency film with a particularly pleasing silvery, translucent quality. It, too, is ideal for those who don't wish to process their own films and it provides the opportunity to show the images in a slide projector as well as making it possible to produce reversal prints. It can be used to create interesting tinted monochrome effects using printing materials such as Ilfochrome.

Orthochromatic films are insensitive to the red end of the spectrum. The first films were of this type and were partly responsible for the soft, luminous quality of the early Victorian photographs.

Lith film is designed to record only pure whites and blacks. It's an effect which can be used to advantage in some situations but as a general rule it's best carried out in the darkroom from a negative first made on conventional film.

Infrared films, such as Ilford SF200, Konica's 750mm infrared and Kodak's high speed infrared are designed to be sensitive to the infrared wavelengths of light and when used with an opaque filter will record only this part of the spectrum. But for most pictorial photography it is used with a red filter which allows both visible light rays and infrared rays to be recorded.

Near Cherbourg – Normandy, France.

**Technical Details**
35mm Single Lens Reflex – 150mm lens,
Kodak 2745 Recording Film developed in DK50.

The Loire valley – France.

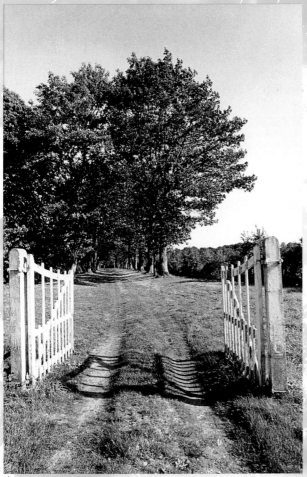

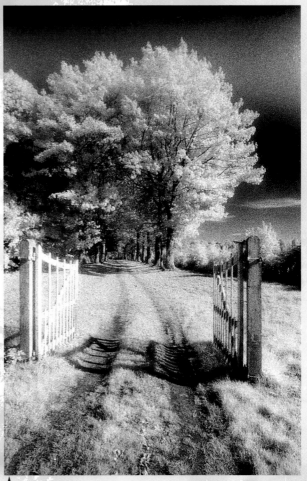

**Technical Details**
35mm Single Lens Reflex – 35mm lens, Ilford FP4 developed in ID11.

**Technical Details**
35mm Single Lens Reflex – 35mm lens, Red Filter,
Kodak High Speed Infrared film developed in DK 50.

These two photographs show the quite dramatic effect which can be created by the use of infrared film when compared to a normal panchromatic film.

The aperture is the device which controls the brightness of the image falling upon the film and is indicated by f stop numbers f 2, f2.8, f4, f5.6, f8, f11, f16, f 22, f32. Each step down, from f2.8 to f4 for example, reduces the amount of light reaching the film by 50per cent and each step up, from f8 to f5.6 for instance, doubles the brightness of the image. The shutter speed settings control the length of time for which the image is allowed to play on the film and, in conjunction with the aperture, control the exposure and density of the image. Many cameras now allow the shutter speed and aperture to be adjusted in one-third or half stop increments.

# Technique

Choice of aperture also influences the depth of field, which is the distance in front and beyond the point at which the lens is focused. At wide apertures, like f2.8, the depth of field is quite limited, making closer and more distant details appear distinctly out of focus.

The effect becomes more pronounced as the focal length of the lens increases and as the focusing distance decreases. So with, say, a 200mm lens focused at two metre and an aperture of f2.8 the range of sharp focus will extend only a short distance in front and behind.

The depth of field increases when a smaller aperture is used and when using a short focal length or wide-angle lens. In this way a 24mm lens focused at, say, 50 metres at an aperture of f22 would provide a wide range of sharp focus extending from quite close to the camera to infinity. A camera with a depth of field preview button will allow you to judge the depth of field in the viewfinder.

Dungeness beach – Kent, UK.

The image above right was given an exposure of 1/500 sec at f4 while the image below right was given an exposure of 1/5 sec at f22. It can be seen that the smaller aperture has increased the depth of field and made the background details significantly sharper. The choice of shutter speed determines the degree of sharpness with which a moving subject will be recorded. With a fast-moving subject, like an animal running for instance, a shutter speed of 1/000 sec or faster will be needed to obtain a sharp image.

Technical Details ▶
35mm Single Lens Reflex –150mm lens, Ilford XP1.

# Technique

When a subject is travelling across the camera's view, **panning** the camera to keep pace with the movement will often make it possible to obtain a sharp image at **slower speeds**. This technique can be used to create the effect where the moving **subject is sharp** but the background has movement blur and can considerably heighten the effect of speed and movement.

Californian rodeo — USA.

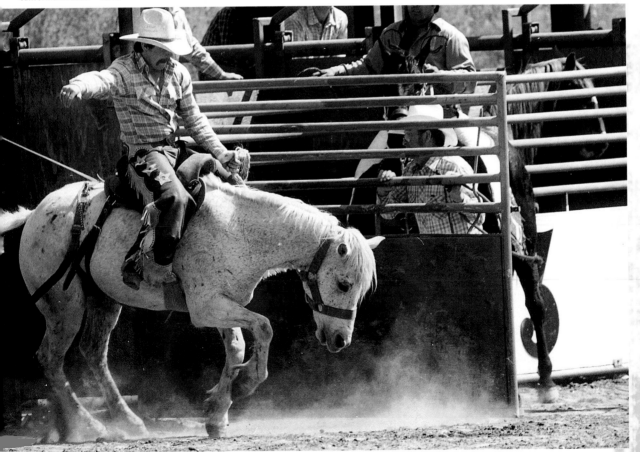

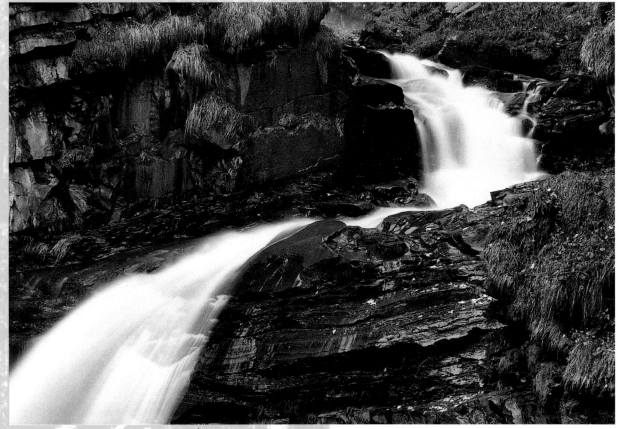

Yosemite – California, USA.

▲ Technical Details
35mm Single Lens Reflex – 150mm lens Ilford XP1.

# Technique

A sharp image of a moving subject is not always the best way of photographing it, however, and in some circumstances a very slow shutter speed can be used to create striking effects when part of the subject is static. A waterfall is a classic example.

A tripod must be used to ensure the static elements of the image are recorded sharply and then a slow shutter speed of, say, one second or more is selected to create a fluid smoke-like effect. The same technique can be applied very successfully to subjects like a busy street at night to record the light trails from moving vehicles. Images like this may need an exposure of several minutes.

I used a shutter speed of 1/500 sec to freeze the movement in this shot of a bucking horse.

◀ Technical Details
35mm Single Lens Reflex – 200mm lens Kodak Tri X developed in D76.

# Understanding Exposure

Modern cameras with automatic exposure systems have made some aspects of achieving good quality images much easier but no system is infallible, and an understanding of how exposure metres work will help to ensure a higher success rate.

An exposure meter, whether it's a built in TTL meter, or a separate hand meter, works on the principle that the subject it is aimed at is a mid-tone, know as an 18per cent grey. In practice, of course, the subject is invariably a mixture of tones and colours but the assumption is still that, if mixed together, like so many pots of different-coloured paints, the resulting blend would still be the same 18per cent grey tone.

With most subjects the reading taken from the whole of the subject will produce a satisfactory exposure. But if there are aspects of a subject which are abnormal – when it contains large areas of very light or dark tones, for example – the reading needs to be modified.

An exposure reading from a white wall, for instance, would, if uncorrected, result in underexposure and record it as grey. In the same way a reading taken from a very dark subject, like a portrait of an African tribesman, for instance, would result in his skin being too light.

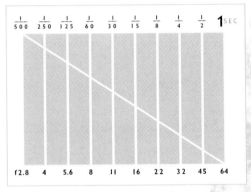

This illustration shows the relationship between shutter speeds and apertures and how a faster shutter speed needs a wider aperture and a smaller aperture needs a slower shutter speed in order to maintain the same exposure.

## Technique

Whichever method of exposure measurement is used though, it's best to regard the exposure as an integral part of the film and developer combination you use. The ISO ratings of black and white films need to be modified according to the development you use, the type of negative you prefer to print from and the particular image quality you wish to achieve.

Many photographers find that by either under-or overexposing their film and adjusting the development times, or types of developer, it's possible to fine-tune the quality of the prints you make to a very significant degree.

Near Hartland Quay – North Devon, UK.

I reduced my exposure reading by one stop in this seascape as the dark-toned rocks caused the exposure meter to indicate more exposure than was necessary.

St Mark's Square, Venice – Italy.

I increased my exposure reading by two stops to allow for the strong back lighting and the very bright sky in this shot. The exposure needs to be decreased when the subject is essentially dark in tone or when there are large areas of shadow close to the camera. With abnormal subjects it is often possible to take a close-up or spot reading from an area which is of average tone.

**Technical Details**
35mm Single Lens Reflex – 150mm lens, Ilford FP4 developed in ID11.

**Technical Details**
6x4.5cm Single Lens Reflex – 55–110mm zoom lens, Ilford XP2.

The Darkroom

4

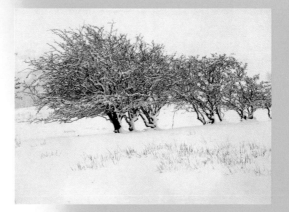

When colour transparency film is used, most of the creative process has already
been completed the moment the exposure is made. But for the black and white photographer
the creative process has only just begun as the darkroom provides almost limitless possibilities
to control the quality and effect of an image.

# The Darkroom & Materials

Setting up a darkroom may seem a rather daunting prospect but, for black and white work in particular, it can be very basic and simple without compromising quality. Ideally a spare room can be used for something fairly permanent, but if this is not possible it's not difficult to have a temporary arrangement in a room which can be easily blacked out. A bathroom is ideal because it has running water but even this is not essential as all but the final wash can be carried out in dishes or tanks.

This illustration shows a suitable layout for a small home darkroom with limited space.

## The sink

With a permanent set-up this would be a large, shallow sink spacious enough to hold four trays or dishes slightly larger than the biggest print you are likely to make. For 16x12" prints, for instance, you would need a bench or sink at least 24" wide by 60" long. Custom-made plastic sinks can be bought in photographic supply stores.

## The safelight

You will need a safelight. You can buy red-tinted safelight bulbs to place in the usual socket but, since you will need white light as well, it's preferable to have a separate box-type safelight with a standard domestic bulb and a sheet of special orange-tinted glass in front. Make sure the safelight screen is the right type for the printing materials you intend to use. Film must be handled in total darkness.

## The enlarger

An enlarger is, of course, the most important piece of equipment and there are many types, at varied prices, to choose from. For black and white printing it can be a simple condenser type or one with a diffusion box. A filter slot will be helpful if you use variable-contrast papers. Make sure the column is firm and long enough to give you enough magnification to produce the largest size of print you anticipate making.

## The lens

Do make sure you buy the best lens you can afford as this will be ultimately responsible for the quality and definition of your prints. Ensure that it is designed to fully cover the film format you use.

## Technique

Blacking out a recessed window is easy using a wooden frame edged with black felt which is made to fit snugly inside and covered with black opaque fabric. You can use six-inch strips of similar black fabric to light proof the door frame. Sit inside for ten minutes or so with the lights off to ensure it really is dark.

# The easel

You will also need a masking easel or some means of holding the printing paper flat during the exposure. A good easel with variable borders which is easily adjusted for different paper sizes is a good investment and makes for more convenient working. A paper safe makes access to your printing paper quick and easy and reduces the possibility of accidental fogging.

# Timers

An electric enlarger timer to control exposure times is desirable as it allows you to repeat exposures easily and accurately, but it's not essential. You will, however, need a good-sized clock with a second hand to measure processing times. A simple interval timer with an alarm is also useful to remind you when washing is completed etc.

# Processing equipment

You will need at least four print developing trays as well as a daylight processing tank and spirals for processing film. These are made both in plastic or, more expensively, in stainless steel. Both are equally suitable. A set of print tongs will save you having to dry your hands each time after processing a print and will reduce the risk of stains.

# Measures

You will need a variety of chemical measures, one for small quantities up to, say, 100ml and others of one or two litres plus a selection of storage bottles. You will also need a good, easy-to-read photographic thermometer.

Near Ullswater – Cumbria, UK.

The thin black border around this print was produced by using an oversized negative carrier and using the negative rebate in the way described.

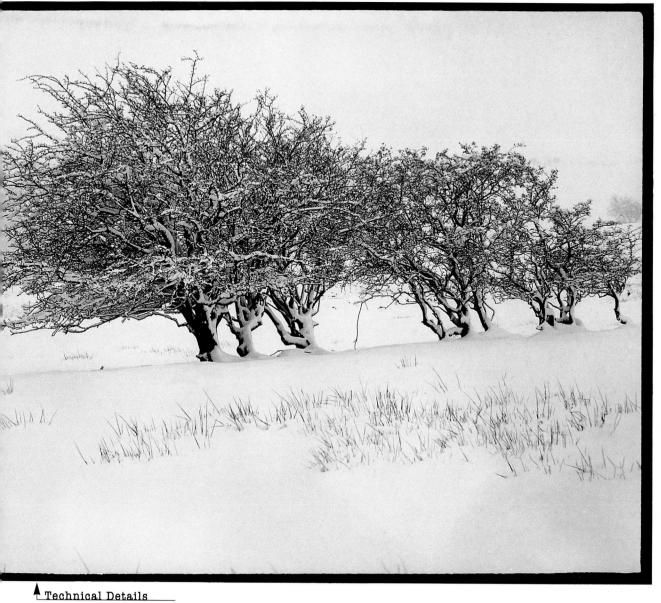

↑ Technical Details

6x4.5cm Single Lens Reflex – 55–110mm zoom lens, Ilford XP2.

## Technique

The usual way of presenting a black and white print is with a plain white
margin, which the easel provides, but it's very fashionable to introduce a thin
**black or grey border** between the image and the white margin.
This is most easily done by using an <span style="font-size:larger">oversize negative</span>
<span style="font-size:larger">carrier</span> so that some of the negatives, rebate provides the margin. Some
workers file away the edges of their negative carriers to give a rough,
<span style="font-size:larger">hand-made</span> look to the border.

# Processing Solutions

Different developing solutions are needed for negatives and prints. In each case it is easiest to opt for concentrated solutions which can be diluted as needed. All the leading film manufacturers, such as Ilford, Kodak, Agfa etc. recommend their own chemicals to process the films they make but there are also a number of independent companies which produce universal chemicals.

You will also need a **stop-bath** solution for both film and paper but this is universal, needing only to be diluted according to instructions for the material in use.

There are different **fixing** solutions for film and paper and, although either will work with the other if needed, it's best to follow the film or paper manufacturer's instructions. A **wetting agent** is to be recommended for the final rinse with both films and papers because it discourages the formation of watermarks and speeds drying. A wash aid is recommended for use with fibre-based papers as it reduces final rinse times and increases **archival** permanence.

A documentary image like this, destined primarily for newspaper or magazine reproduction, might best be printed on a resin-coated paper for its speed of processing and greater convenience in use.

**Technical Details** ➤
35mm Single Lens Reflex— 24mm lens, Kodak Tri X developed in Unitol.

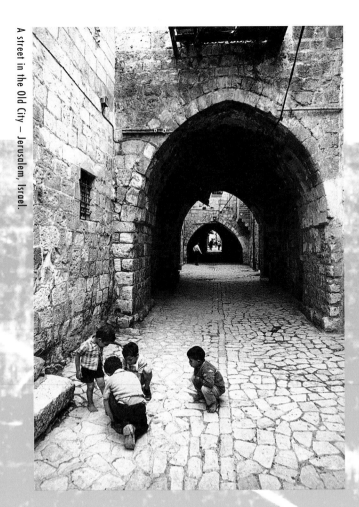

A street in the Old City – Jerusalem, Israel.

# Printing Papers

There is a choice of two basic types of paper – fibre-based or resin-coated. The latter is easier to handle, quicker to process and it dries naturally flat. It is ideal for contact prints and everyday use with the potential to produce extremely high-quality prints.

Fibre-based papers have a visual and tactile quality along with the ability to produce a particularly lustrous image, making them the best choice for portfolio and exhibition work.

Both fibre-based (FB) and resin-coated (RC) printing papers are available in fixed paper contrast grades – usually from zero (soft) to five (hard) – and also as variable contrast materials which need only a change of filtration to alter the image contrast. The latter enables you to have only one packet of paper for each size of print you wish to make.

The recreation ground, Sevenoaks – Kent, UK.

A fibre-based paper would be a more appropriate choice for a more "arty" image like this shot of an old park bench, printed largely to achieve a graphic effect with a portfolio or exhibition in mind.

## Technical Details ▶
35mm Single Lens Reflex  – 24mm lens, Ilford FP4 developed in Agfa Rodinal.

# Developing Film

The easiest way to process black and white 35mm or roll-film is in a daylight developing tank. This involves loading the film into a spiral in complete darkness and then placing it into the tank. Once the lid is in place the remaining processes can be carried out in normal lighting. Loading a film spiral is not difficult but it takes a little practice. This is best done initially in daylight using an unwanted roll of film – one which is out of date perhaps.

## You will need

You'll need film developer and, for processing one or two rolls at intermittent periods, it can be best to opt for a one-shot developer, in which a concentrated solution is diluted, used once and then discarded to ensure consistency of results. You will also need a stop bath and a film fixing solution. These solutions, once mixed up, can be retained for repeated use up to the recommended limit if stored in airtight bottles.

## Processing control

The development process is dependent upon the time the film is in the solution, the degree to which it is agitated and the temperature of the developer. These factors must be carefully controlled on each occasion to ensure consistent negative quality.

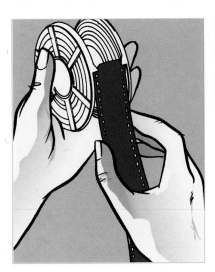 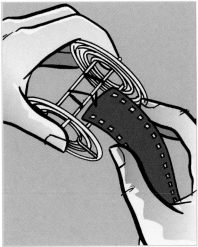

These illustrations show the way a film spiral is loaded. Film is pushed inwards from the outside with the plastic spirals while, with stainless steel spirals, the film is clipped to the centre and wound outward.

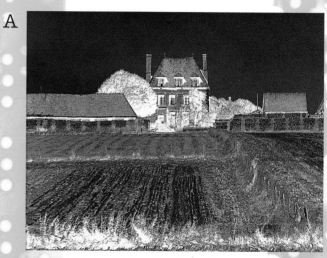

# Assessing the negatives

Hold the negatives over a lightbox or a well-lit piece of white paper. Correctly exposed and developed negatives should show some detail in both the thinnest and densest parts of the image and they should have good, but not excessive, contrast.

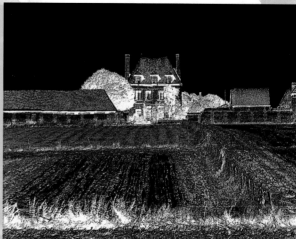

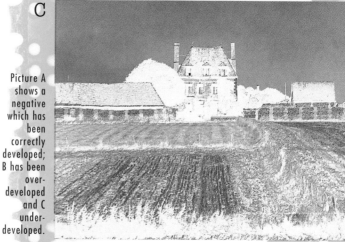

Picture A shows a negative which has been correctly developed; B has been over-developed and C under-developed.

## Step 2

Ten seconds before the development time elapses, pour the used solution **away** quickly and smoothly and **replace** it in the same way by the stop bath. Agitate and leave for the recommended time.

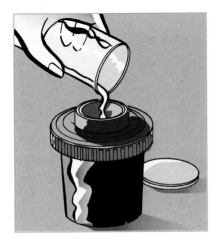

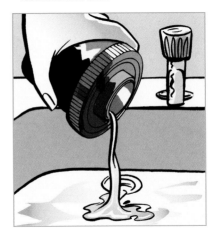

## Step 1

When the film is loaded, ensure the developer is at the correct **temperature** and pour it into the tank **quickly** and smoothly. Agitate by inverting the tank periodically for ten seconds or so each minute.

## Step 3

Pour out the stop bath, reserving it for future use, pour in the fixing solution and **agitate**. After a minute or so it is safe to remove the tank lid and take a **peek**, but be sure to allow the film to **remain** in the fix for the **recommended time**. Reserve your fix after use – it can be reused.

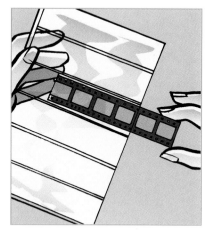

## Step 5

As soon as the film has dried it should be cut into
**strips** of convenient lengths – usually six or
seven frames for 35mm and three or four for 120 –
and placed immediately into **protective**
negative sleeves.

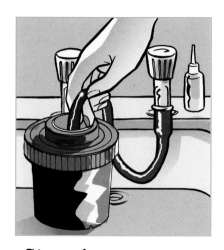

## Step 4

After fixing is **completed** the film must be washed in
**running water** for at least half an hour before hanging it
up to dry on a line in a dust-free atmosphere. If you add a drop or
two of wetting agent to the final wash water it should dry without
runs or watermarks. It's best to **avoid** wiping or
**squeegeeing** the wet film as it is easily **damaged**
at this stage. You can buy special clips, but clothes pegs are just
as good – fasten two or three on to the bottom for weight to
ensure the film dries straight.

# Making a Print

Before making an enlargement it is very
helpful to make a set of contact prints – this will make it easier for
you to assess the negatives and to select the best ones.

## Step 1

Set your enlarger, without a negative in the carrier, so that it
projects a rectangle of light on to the baseboard
which is somewhat larger than a sheet of the paper size
you will be using. To contact a complete roll of 35mm or
120 film comfortably you will need to use 12x8" or 12x10"
paper.

## Step 2

With the room light off, and the red safety filter in place
under the enlarger lens, place a sheet of paper – it's best to
start with a normal contrast, grade two paper – within the
illuminated rectangle and lay the strips of negatives,
emulsion-side down, in rows upon it. Place a
clean piece of plate glass, cut slightly larger than the
paper size, on top to hold the negatives in close contact
with the paper. (You can buy special contact printing frames
which can make this a little easier.)

4

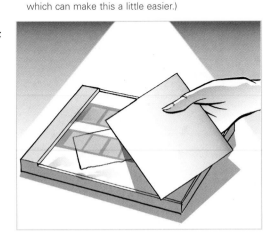

## Step 3

The correct exposure, made by swinging the red
filter away, depends upon a number of variable
factors, such as the type of paper you are using, the
density of the negatives, the brightness of
your enlarger lamp and the aperture you set on the
enlarger lens – so you will need to make a test.

## Step 4

With your enlarger lens set to, say, f5.6, give an exposure of
five seconds then cover 1/6th of the paper with
a piece of black card. Now give an additional
exposure of two seconds, then slide the black card
over to cover another sixth of the paper. Repeat this four
more times, giving three second, four second, five second
and ten second exposures. You now need to process the
paper. The resulting test strip will show the effect of
exposures of five, seven, ten, 14, 20 and 30 seconds.

## Step 5

Have your chemicals mixed ready in their dishes at the
correct temperature, according to the instructions
and set them out with the developer, stop bath, fixing bath
and rinse in a row. Make sure there is enough space
between the dishes to minimise the risk of
contamination. Place the exposed paper in the
developer, sliding it in, emulsion-side up, quickly and
smoothly, then agitate the dish by rocking it gently from
side to side for the recommended time.

## Step 6

Ten seconds before the full time elapses, remove the
print gently by one corner and allow the developer to
drain back into the dish before repeating the process
with the stop bath and fixer. After 30 seconds or so it is
safe to switch on the room light and take a look, but
leave it in the fix until the recommended time is up.

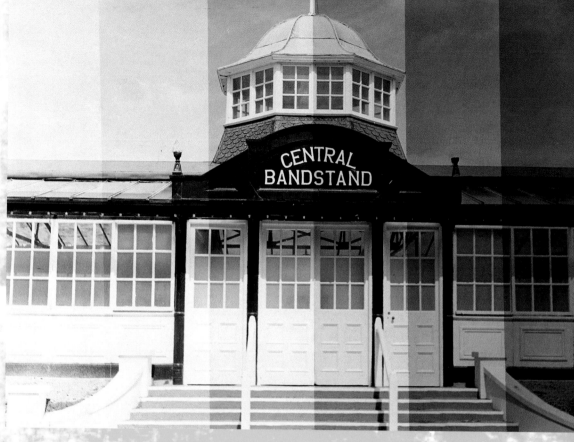

## Step 7

The print must next be washed in running water.
For fibre-based papers, and where the greatest
permanence is required, it's best to use a wash
aid first and to allow the print to rinse for the full
recommended time. With resin-coated
papers the safe washing and drying times are much
shorter.

## Step 8

The easiest way to dry resin-coated prints is by
squeegeeing the surface dry and then
hanging them from a line by one corner. But it's best
to dry fibre-based papers on a print dryer to
ensure they dry flat. If you don't have one, squeegee
two fibre-based prints and then peg them together
back-to-back by all four corners and hang to
dry for a flatter result. You can also tape a still, damp
FB print by each edge to a support such as hardboard
or glass.

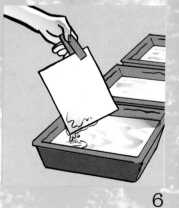

5

6

## Assessing the print

If the print is too dark or too light all over repeat the process giving less exposure, if the print is too dark, and more if it is too light. This can be done either by adjusting the aperture of the enlarger lens or by doubling or halving the exposure increments. If the print is too soft or too contrasty, change to either a harder (grade three) or softer (grade one) paper. If you have chosen to use variable-contrast paper simply alter the filtration as indicated. It's best to judge your prints after they have been washed and dried, and in daylight. For contact prints it's usually good enough to make an assessment while they're still wet.

## Making an enlargement

Having selected your negative, the process of making an enlargement is almost identical but with the exception, of course, that you place your negative in the enlarger carrier and project the image of the required size on to your enlarger easel. You will find a focusing magnifier a very useful means of ensuring your prints are in sharp focus.

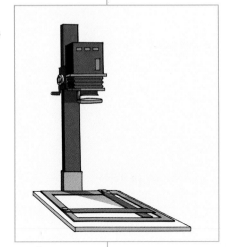

An Enlarger.

These three photographs show the effects of using different paper grades. The first was printed on normal paper.

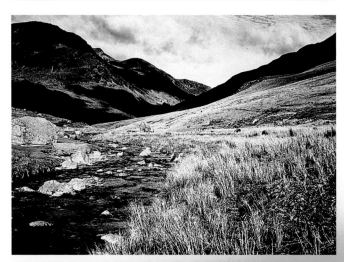

The second was printed on hard grade paper (grade zero).

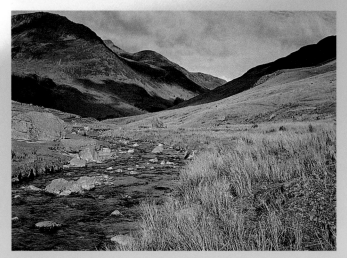

The third version was printed on soft paper (grade five).

# Fine–tuning the Print

Don't be too disappointed if your first print is not as good as you'd like. The craft of black and white printing lies in making quite fine adjustments to the contrast and density of the image and this is often difficult to achieve without making several prints or test strips.

## Technique

With creative work – images which are intended as a personal expression rather than a factual record of a scene – such considerations are irrelevant and it's necessary only to achieve the effect which most closely matches the way you visualised the image at the time you took the photograph. Or, during the process of printing you may discover a hitherto unnoticed latent quality in the image which you can now emphasise.

## Shading

Having decided which is the best exposure, and established the most suitable level of contrast overall, you can now look at individual areas of the image to see if they can be altered to advantage. Shading is the process of giving additional or less exposure to the tones within the image which you feel are too light or too dark. It is the most basic form of print manipulation and it can do a great deal towards bringing the image closer to the way you have visualised it.

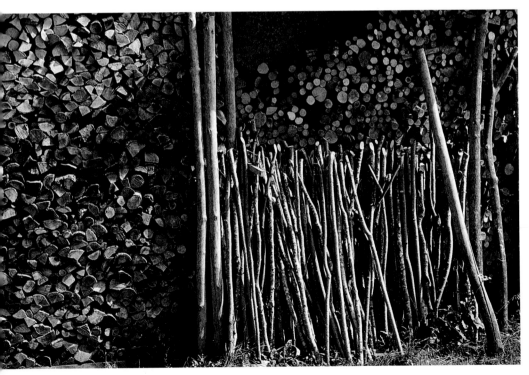

This print has been given an exposure on a grade of paper which shows a full range of tones and has produced an image of normal contrast – a technically good-quality print.

# Printing in

Printing in is the process of giving additional exposure to the tones within the image which you feel are too light. To make an area darker, first give the basic overall exposure and then, without moving the paper, give an additional exposure to the chosen area, using your hand or a piece of card cut to shape to shield the rest of the image while this is done. When you need to make a quite small central area darker you can cut a hole to the right shape in a larger piece of card.

# Technique

Perhaps the most common control of this type is to make the sky darker in a landscape shot, and often such areas, when brightly lit, will need as much as 200 per cent or 300 per cent extra exposure. It's important to keep your hand, or piece of card, moving slightly as you make the subsequent exposures to ensure the transition of darker tone is gradual and undetectable.

A

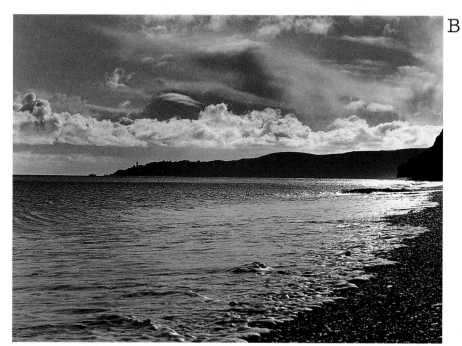

B

These two prints show the effect of fine-tuning the image. Picture A is a straight print on a normal grade of paper. Picture B is the result of printing on a half-grade harder paper with 10 per cent more exposure and printing in the sky by an additional 200 per cent.

# Fine–tuning the Print

## Technique

With variable contrast papers it is possible to use shading techniques to give selected areas of the image greater or less contrast by changing the filtration for the extra exposures.

## Dodging

Making an area lighter is the same process in reverse, but in this case you hold your hand or piece of card over the selected area of the image during the basic exposure for a percentage of the time. When you want to make small central areas of the image lighter you can use a length of thin wire to hold a small piece of card in place. Cut it to the shape of the area you wish to lighten, and tape it to one end of the wire. A piece of plasticine is also useful for this as it can be moulded into a variety of shapes as required. Again, it's necessary to keep the dodger moving slightly during the exposure.

## Technique

Another effective method of making selected tones lighter is by bleaching them after the print has been processed. A solution called Farmers Reducer is used – a dilute solution of potassium ferricyanide and hypo, it can be bought ready for use. Use a sable brush to apply it to the areas you wish to make lighter or use a cotton-wool swab for larger areas. The solution will act quite swiftly and you can stop it instantly by placing the print back in a dish of fixer. The print must be fully re-fixed and washed after this treatment.

### Rule of Thumb

It's best to make a quick sketch or map of your shading and dodging times – and the areas you've manipulated in this way, so they can be repeated easily.

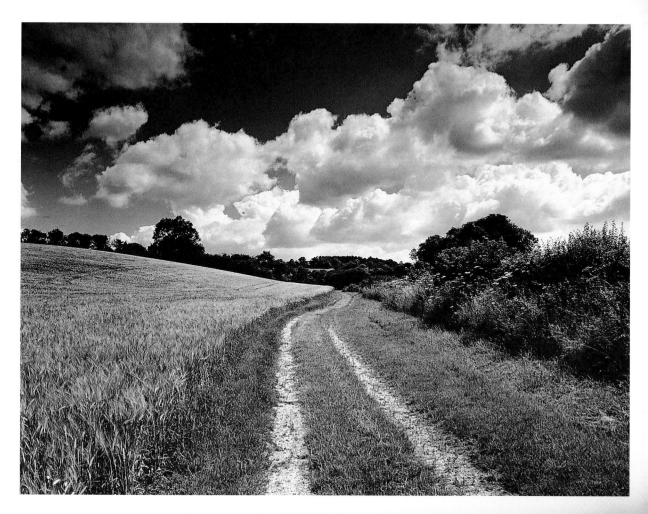

This print shows the effect of quite extensive shading as indicated on the accompanying diagram. The diagram makes it easier to modify or repeat the shading technique accurately on future attempts.

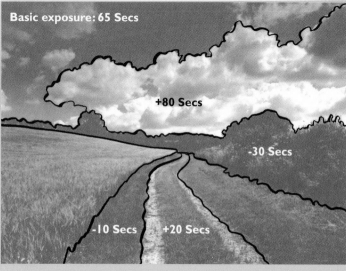

**Basic exposure: 65 Secs**

+80 Secs

-30 Secs

-10 Secs    +20 Secs

Once you have the ability to make good-quality prints
from your negatives there are a number of special effects which can be explored
to give your images additional interest and impact.

# Montage printing

This is a means of combining the images from
two or more negatives on to the same print.
Although not necessarily difficult, it does require a
methodical way of working. You must first
select the images to be combined with some care as
they need to be compatible in terms of
contrast and lighting quality.

## Technique

An effective use of this technique is to combine a
photograph like a landscape which has a blank,
or uninteresting sky with a more dramatic
sky from another negative.

### Step 1

Size up the host image on the enlarger easel –
in this case the landscape – and ensure that
you have enough space at the top to
accommodate the new sky you will be adding.

### Step 2

Place a piece of white paper in the easel and make a
trace of the main outlines of the image,
including, especially, the horizon. Make a test
strip in the normal way to establish the correct
exposure.

### Step 3

Now expose a print from this negative, holding back
any unwanted detail in the sky by shading. You must
ensure that you know which way the paper was
placed into the easel – folding over one corner is
an easy way.

### Step 4

When it's exposed, place the paper in a light-tight
box, take the landscape negative out of the enlarger
carrier and size-up the negative of the sky
using the tracing as a guide.

### Step 5

Make a further test strip to establish the
exposure for this image and then place the
already exposed paper back into the easel in the
same position as before.

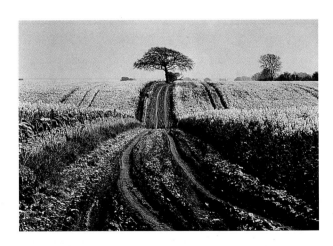

## Step 6

Now make the sky exposure but **holding back** any unwanted detail, by shading, which will overlap with the already-exposed landscape part of the image.

## Step 7

The **combined** print may now be **processed** in the normal way. It's quite likely that you will need to make **several attempts** as the line between the two images needs to be carefully **vignetted** in order to make a **convincing** join.

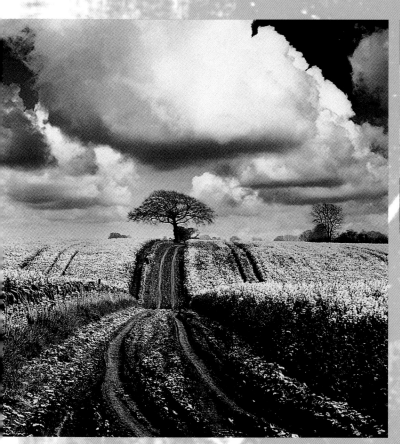

These three images show how two negatives have been combined in a montage print in the way described. One has been used for the sky area and the other for the foreground landscape.

## Printing Effects

# Technique

It can also be interesting to let the images overlap so one 'sees through' to another. Where this happens you will need to shade the overlap area of each, otherwise it will be overexposed and become too dark. The key to this technique is to remember that as you add other images they need to be projected on to an area of the existing exposure that is either unexposed or very light in tone.

# Technique

In the technique described on the previous page you will be trying to **disguise** the fact that two images have been combined into one but this technique can also be used very effectively to create **deliberately** strange and **ambiguous** effects and you can, with practice, combine several images in this way.

Left: A section of a nude has been added to the sky area of a landscape in a similar way to the previous image but with a very different intent.

Opposite: In this image a close-up of an eye was printed into the sky of a landscape shot. A hole was created in the latter by vignetting with an eye-shaped dodger and the eye was similarly vignetted into it using a same-shaped hole cut into a piece of black card.

## Texture screens

Texture screens are a simple tool for adding an unusual and eye-catching quality to an image. This involves placing a piece of film, translucent paper or fabric in contact with the negative in the enlarger carrier. It's possible to buy ready-made texture screens with effects like canvas and silk, but it's more satisfying to create you own. One of the most pleasing effects is to use the paper from which negative sleeves are made – it produces an attractive crystalline quality.

## Technique

You can also produce your own texture screens in the camera by making thin negatives of textured surfaces – or indeed anything with fairly fine, even detail – with an essentially clear-film or shadowy background.

This print was made by placing a very thin piece of tissue paper in contact with the negative.

This effect was created using a piece of translucent negative storage bag in contact with the negative.

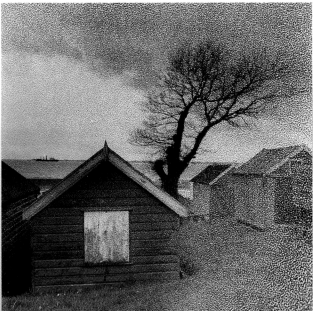

For this effect a sheet of acetate, taken from a portfolio sleeve, was placed in contact with the printing paper and held flat with a piece of glass.

# Afterwork & Presentation

It's most important to handle both negatives and printing materials carefully during processing but, even so, it is unusual if a print does not require some tidying up before it can be considered finished.

## Spotting

The most common problem is the presence of small white spots caused by dust on the negative. These are particularly noticeable in areas of even tone and when large degrees of enlargement are involved. To remove these you need a small, fine-tipped sable brush and watercolour dyes to match the image colour of your print. It's possible to buy small kits which contain the most common image tints, such as warm black, brown-black and blue-black, etc.

## Technique

The trick is to keep the brush as dry as possible and just use the very tip in a stippling action. It helps to make up a colour, by dilution, slightly lighter than the tone surrounding the spot you wish to remove and to build it up by repeated applications, and not by attempting to 'paint' the whole mark in one go.

## Bleaching

Dark or black marks are rather more difficult to remove, but fortunately they occur much less frequently. It's possible to bleach these marks with Farmers Reducer which can be applied with a fine-tipped brush. In this way, the offending dark spot can be bleached back to white and then spotted back with watercolour dye to the right tone. It's more easily done on a damp-dry print which must be re-washed after treatment. Another solution is to use a sharp scalpel blade to very gently scrape away at the offending area, removing minute layers of the emulsion until the tone matches its surroundings. This will, however, leave a perceptible surface mark on the paper.

## Mounting

Even the finest print will be improved by good presentation and mounting it flat on to a heavyweight card is the first stage. Resin-coated papers are relatively easy to mount as they dry naturally flat and a simple adhesive spray-mount will do the job well. But fibre-based papers can present more of a problem unless some care is taken to ensure they are dried flat.

### Rule of Thumb

For portfolio and exhibition prints, and those where archival permanence is required, dry mounting is not favoured. It's best to hold the print in place on the mounting board with acid-free tape across the corners and then complete the presentation by placing a bevelled cut-out mount on top to frame it. You can cut these yourself to size using a craft knife or with a special tool, but they can also be bought ready-made in the most popular sizes from art stores.

## Technique

Dry mounting ensures a perfectly flat, mounted print; this involves placing a sheet of adhesive tissue between the print and its mount and applying heat and pressure, ideally with a dry-mounting press, although a domestic iron will do.

Building up a body of work is one of the most stimulating and challenging projects for a photographer, and the formation of a portfolio is the best way to do this. Prints can either be displayed in a portfolio album, in which they are protected by clear plastic sleeves, or individually mounted and kept in a portfolio box or case.

## Exhibitions

These are a rewarding way of finding a wider audience for your work, and a regular check in the photographic magazines will provide you with a list of venues. Postal portfolios are another way of showing your work to others and exchanging ideas. Perhaps one of the most satisfying ways of displaying your talents is to join an organisation like the Royal Photographic Society and to submit your portfolio to a judging panel with a view to gaining a distinction.

# Toning & Tinting

Producing a black and white print is not necessarily the end of the creative process. Image colour can have a striking effect on the appeal and quality of an image and chemical toning is frequently used to add impact and interest; it's a process which can be carried out in normal lighting conditions.

## Lith paper

Lith materials are intended to reproduce images as pure black and white with no mid-tones. However, many black and white photographers use them to produce prints with a full tonal range but with a different image colour and most unusual quality.

It requires some experimentation, but the principle is to overexpose the negative on to a suitable paper, such as Kentmere's Kentona, and then develop it in diluted lith developer, withdrawing it before completion. The subsequent prints can then be toned to give a further range of effects.

## Selenium toning

One of the most basic forms of toning is that of selenium toning which adds a very subtle richness and colour change to an otherwise straightforward black and white print and also lith prints. It has the added benefit of making the resulting prints very resistant to fading and discolouration, making it ideal for exhibition and portfolio work, and where archival permanence is important.

## Technique

Split toning is when the action of a dilute solution is halted before it affects the whole image. Depending on the printing materials used, it can create an image with a subtle colour difference between the highlights and shadows.

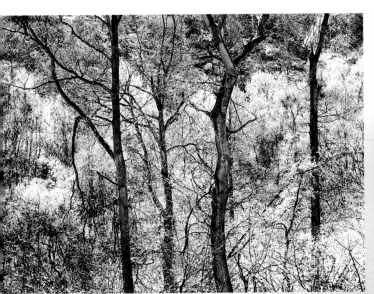

These two images show the effect created by printing on to lith paper when compared with a normal bromide print. The larger image was given approximately three times the normal exposure on to Kentmere Kentona paper and then processed in diluted lith developer, only removed when the highlights had reached the required density.

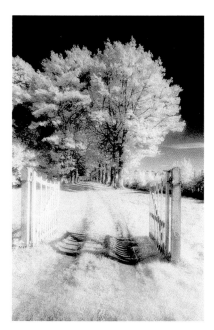
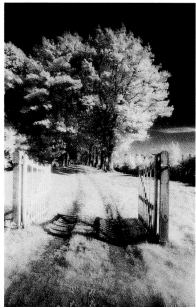

<div style="border:1px dashed">

**Rule of Thumb**

For all toning processes it is vital that the print is fully fixed and thoroughly washed before any further work is carried out as these processes can easily cause staining. From this point of view it is easier to work with resin-coated papers than fibre-based ones.

</div>

These two identical black and white prints were colour toned, one in a green toner and the other in sepia.

# Colour toning

Most people are familiar with the sepia-toned images of the Victorian era and this process is still often used to vary the image colour of modern printing materials. There are a variety of chemical toners which can be used individually, and in conjunction with each other, to produce colours ranging from dark brown to red, blue and green. Some require the black and white print to first be bleached and then subsequently redeveloped, while others work directly upon the black and white image. There are many subtle variations of colour which can be created by repeating the process of partial bleaching and redevelopment. It's not an exact science and the best results are often the result of considerable experimentation.

# Toning & Tinting

## Technique

It's possible to buy a kit of chemical toners and dyes called Colorvir which can be used to create a very wide range of colours and other effects, including that of pseudo-solarisation, where the image is partially reversed to create a mixture of negative and positive tones within the same image.

## Vintage processes

In addition to toning conventional black and white prints, there are a number of old processes which have been revived in recent times and these can produce very pleasing effects. These include cyanotypes, platinum prints and kallitypes and can be bought in kit form from some specialist photographic stores.

The effect of these two images was created by using the Colorvir chemicals to tone, solarise and dye two normal black and white prints.

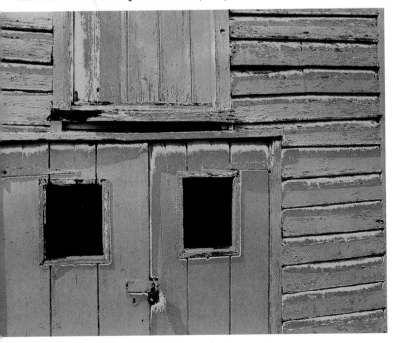
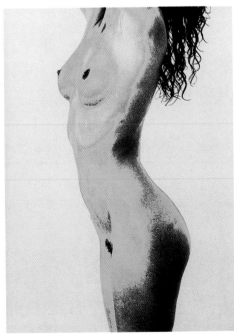

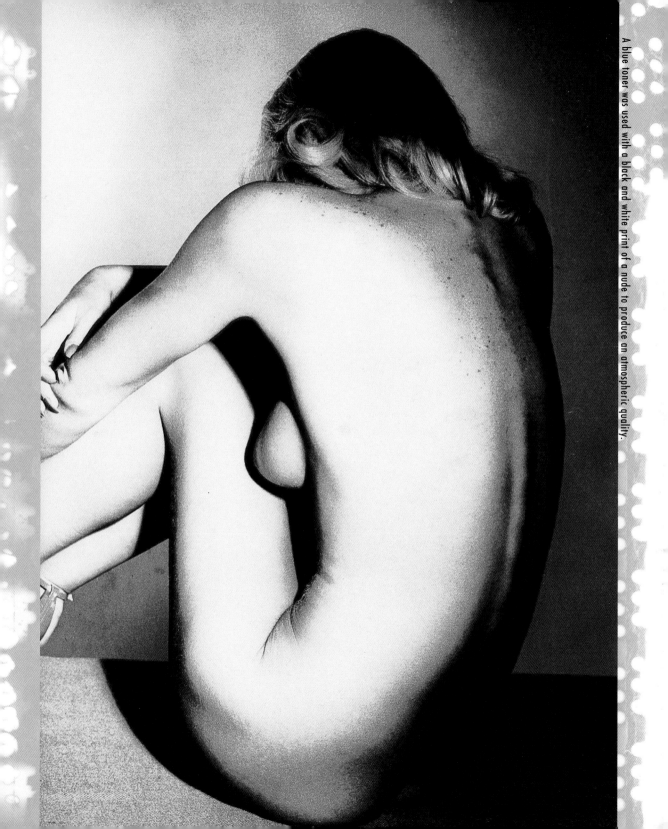

## Toning & Tinting

## Technique

These processes involve coating a piece of paper with a chemical solution which allows the photographer to use a variety of bases such as textured watercolour paper and fabrics. The papers made in this way must be exposed by contact, so a negative the same size as the final print size required needs to be made first. The chemicals are sensitive to ultra violet light, enabling the coating process to be carried out safely in artificial lighting, but the prints must be exposed by sunlight or by a UV lamp.

## Hand colouring

This craft has retained its appeal to many of today's black and white photographers. Oil colours can be used but it's possible to buy a set of transparent watercolour dyes specially for this purpose. They should be applied to a damp-dry print, using fine sable brushes for small details and cotton buds and swabs for larger areas.

## Technique

Unless you are especially skilled with a brush, it can often be more effective to use colours quite subtly and sparingly on selected details of the image, rather than attempting to colour it all, and it can sometimes be a benefit to use a toned print, such as sepia, as a base instead of a pure black and white image.

The Kallitype process, used in the way described above, was used for this landscape image.

A sepia-toned black and white print was used for this hand-coloured image, done quite sparingly, in the way described.

# Glossary

## Aperture Priority

An auto-exposure setting in which the user selects the aperture and the camera's exposure system sets the appropriate shutter speed.

## APO lens

A highly-corrected lens which is designed to give optimum definition at wide apertures. It is most often available as better quality long-focus lenses for subjects likes sports and wild life photography.

## Auto Bracketing

A facility available on many cameras which allows three or more exposures to be taken automatically in quick succession giving both more and less than the calculated exposure. Usually adjustable in increments of one third, half or one stop settings and especially useful when shooting colour transparency film.

## Bellows Unit

An adjustable device which allows the lens to be extended from the camera body to focus at very close distances.

## Bounced Flash

The technique of reflecting the light from a flash gun from a white ceiling or wall in order to diffuse and soften the light.

## Bromide Paper

A printing paper which gives a blue-black image when the appropriate developer is used.

## Cable Release

A flexible device which attaches to the camera's shutter release mechanism and which allows the shutter to be fired without touching the camera.

## Chlorobromide Paper

A printing paper which gives a warm, brown-black image when used with the appropriate developer.

## Data Back

A camera attachment which allows information like the time, and date to be printed on the film alongside, or within the images.

## Dedicated Flash

A flash gun which connects to the camera's metering system and controls the power of the flash to produce a correct exposure. This also works when the flash is bounced or diffused.

## Depth of Field

The distance in front and behind the point at which a lens is focused which will be rendered acceptably sharp. It increases when the aperture is made smaller and extends about two thirds behind the point of focus and one third in front. The depth of field becomes smaller when the lens is focused at close distances. A scale indicating depth of field for each aperture is marked on most lens mounts and it can also be judged visually on SLR cameras which have a depth of field preview button.

## DX Coding

A system whereby an automatic camera reads the film speed from a bar code printed on the cassette and sets it automatically.

## Evaluative Metering

An exposure meter setting in which brightness levels are measured from various segments of the image and the

results used to compute an average. It's designed to reduce the risk of under - or overexposing subjects with an abnormal tonal range.

## Exposure Compensation

A setting which can be used to give less or more exposure when using the camera's auto-exposure system for subjects which have an abnormal tonal range. Usually adjustable in one third of a stop increments.

## Extension Tubes

Tubes of varying lengths which can be fitted between the camera body and lens used to allow it to focus at close distances. Usually available in sets of three varying widths.

## Fill In Flash

A camera setting, for use with dedicated flash guns, which controls the light output from a flash unit to be balanced with the subject's ambient lighting when this is too contrasty or there are deep shadows.

## Filter Factor

An indication of the amount the exposure needs to be increased to allow for the use of a filter, a x 2 filter needs one stop extra exposure, x 3 one-and a-half stops more and x 4 two stops more, and so on.

## Fogging

The effect of exposing film or paper to unsafe ambient light, often caused by a light leak in a darkroom or a safelight which is too bright or has the wrong screen. A good test for this is to place an opaque object, like a coin, on a piece of photographic paper and leave it for twenty minutes or so in the darkroom before processing it.

## Grain

The structure of a film's emulsion which can become visible at high degrees of enlargement. It is more prominent with fast films and can be used for creative effect.

## Hypo Eliminator

A solution which can be used to reduce the amount of time a fibre-based print needs to be washed for archival permanence.

## ISO Rating

The standard by which film speeds are measured. Most films fall within the range of ISO 25 to ISO 1600. A film with double the ISO rating needs one stop less exposure and a film with half the ISO rating needs one stop more exposure. The rating is subdivided into one third of a stop settings ie. 50, 64, 80,100.

## Macro Lens

A lens which is designed to focus at close distances to give a life-size image of a subject.

## Matrix metering

See Evaluative metering.

## Mirror Lock

A device which allows the mirror of an SLR to be flipped up before the exposure is made to reduce vibration and avoid loss of sharpness when shooting close ups or using a long-focus lens.

## Orthochromatic

A film which is not sensitive to red and can be handled with an appropriate safelight.

## Programmed Exposure

An auto-exposure setting in which the camera's metering system sets both aperture and shutter speed according the subject matter and lighting conditions. Usually offering choices like landscape, close up, portrait, action etc.

## Reciprocity Failure

The effect when very long exposures are given. Some films become effectively slower when exposures of more than one second are given and doubling the length of the exposure does not have as much effect as opening up the aperture by one stop.

## Split Grade Printing

This technique of using different levels of contrast for specific areas of an image when making prints on a varicontrast paper.

## Spot Metering

A means of measuring the exposure from a small and precise area of the image –it is often an option with SLR cameras. It is effective when calculating the exposure from high-contrast subjects or those with an abnormal tonal range.

## Stop Bath

An acidic solution which halts the action of the developer when processing black and white film and papers.

## Varicontrast Paper

A printing paper with which the contrast can be altered by the use of coloured filters, also known as Multigrade.